TEA IN THE GARDEN
Quilts for a Summer Afternoon

Cynthia Tomaszewski

Martingale®
& COMPANY

Tea in the Garden: Quilts for a Summer Afternoon
© 2005 by Cynthia Tomaszewski

Printed in China

10 09 08 07 06 05 8 7 6 5 4 3 2 1

Martingale®
& COMPANY

That Patchwork Place®

That Patchwork Place® is an imprint of
Martingale & Company®.

Martingale & Company
20205 144th Avenue NE
Woodinville, WA 98072-8478 USA
www.martingale-pub.com

Library of Congress Cataloging-in-Publication Data

Tomaszewski, Cynthia.
 Tea in the garden : quilts for a summer afternoon /
Cynthia Tomaszewski.
 p. cm.
 ISBN 1-56477-600-X
 1. Patchwork—Patterns. 2. Appliqué—Patterns.
3. Quilting. 4. Muffins. 5. Flowers in art. I. Title.
 TT835.T647 2005
 746.46'041—dc22
 2005008698

Credits

President: Nancy J. Martin

CEO: Daniel J. Martin

VP and General Manager: Tom Wierzbicki

Publisher: Jane Hamada

Editorial Director: Mary V. Green

Managing Editor: Tina Cook

Technical Editor: Ellen Pahl

Copy Editor: Melissa Bryan

Design Director: Stan Green

Illustrator: Laurel Strand

Cover and Text Designer: Shelly Garrison

Photographer: Brent Kane

Mission Statement
Dedicated to providing quality products
and service to inspire creativity.

DEDICATION

To my mom with love . . . for all the times I can say,
"My mom taught me," for the smiles, the hugs, the love,
the sacrifices, and the fun. Thanks, Mom!

My mom,
Rogene Franklin Freed,
1951

VERY SPECIAL THANKS

To my husband, Mike. Thank you for all your love,
continuous support and encouragement, and for truthful,
honest answers when I need them.

To Donna Ward of Hamilton, New Zealand. A big hug of
thanks for machine quilting all of the quilts in this book.
You do fabulous work!

To the staff of Martingale & Company. It's a privilege
and pure pleasure to work with you.

And to all my family and friends. I'm so glad you are
part of my life. You make each day special.

Contents

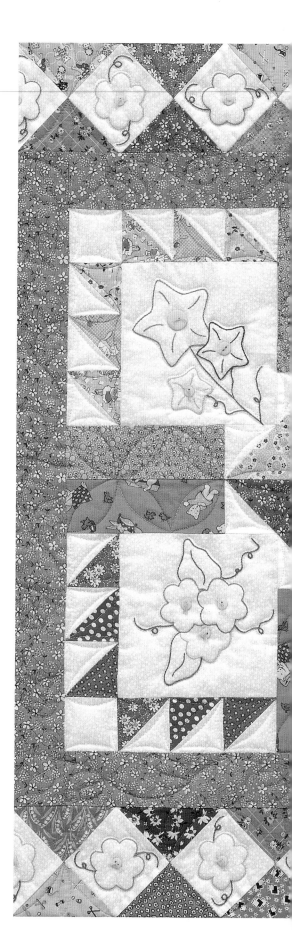

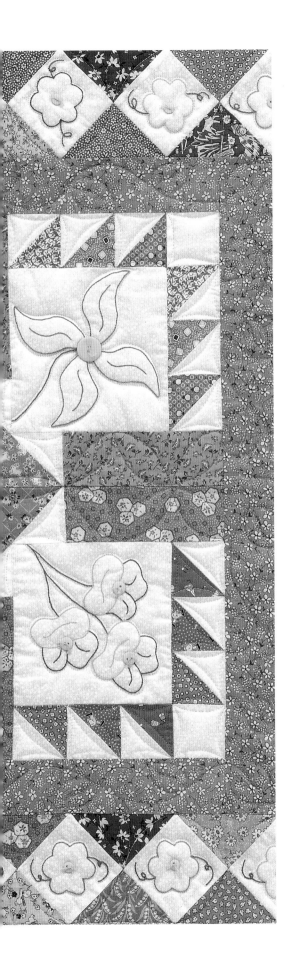

\mathcal{P}REFACE

I think I've finally figured out this quilting thing. It's big. Huge! It's not just a hobby or about what we *do*. It's much more than that. It impacts our daily lives, it directs our actions and our thoughts, and it feeds our souls. Quilting defines who we are. When someone says to you, "I'm a quilter," you will find that the statement means a whole lot more than that she makes quilts.

It starts very innocently. We see a quilt that is beautiful and we think, "I'd like to make one of those." A class is offered in quiltmaking—we find it's not a fast process. First we must choose the fabric—such a wonderful array of fabulous colors, so many prints and patterns, so many possible combinations. The choices are endless. It is difficult to choose just the right ones. Our minds are spinning out of control. We are already eager to complete this project so we can start the next.

We purchase the tools we will need. They will make each step faster, easier, and more accurate. Each phase of the process presents new challenges. We learn. We grow. We produce something with our own hands, something tangible, something usable, something beautiful.

In our classes we meet other quilters. Some are more experienced, some less. All have their own personal insights. All have something to

offer, something to share. We meet on a regular basis and we become friends. We watch their progress and their growth. We share our mistakes and our triumphs. We share our version of each technique and what works best for us. It's a bonding process. We share a common goal. Friendships formed in quilting last long after the class is over, long after life takes us in different directions.

Life is full of duty: jobs, daily chores, endless errands that we do for our loved ones and for ourselves. Though they are appreciated, those same demands will be there again tomorrow, and the day after, and the day after that. As Eliza Calvert Hall writes in her book *A Quilter's Wisdom—Conversations with Aunt Jane*, "If a woman was to see all the dishes that she had to wash before she died, piled up before her in one pile, she'd lie down and die right then and there." Quilting is our creative outlet. Quilting picks us up. It calms us down. It's on our minds as we wash the dishes, do the laundry, clean house, pick up the dry cleaning, walk the dog, and shop for groceries. We see quilt patterns on cereal boxes and in the designs of tile floors. We eye the fabric of other passengers' clothing on the elevator with a possessive eye. We plan our quilts in our minds, each step of the process. During our daily rush we crave the luxury of

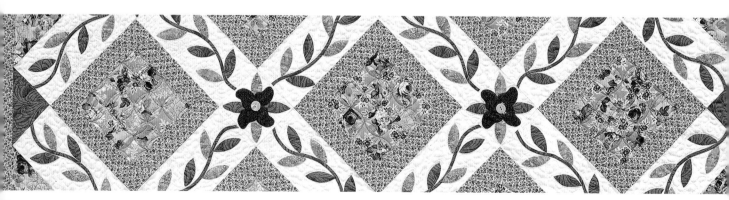

time to create. And when we find those few precious minutes or hours, we are ready.

There is room for everyone in quilting—the young, the old, the rich, and the poor. It crosses all cultural and religious barriers. It is so exciting to see the exchange of ideas and experience between the generations. When I was a young girl my mother taught me to sew. Later in life I taught her to quilt. The woman who taught me to quilt lived at the end of a dirt road, in a very small, modest home on the backwater of Chesapeake Bay. She made her quilts completely by hand, using cereal boxes to construct her templates. Her only tools were cardboard, scissors, needles, a pencil, and a ruler. She drafted her own patterns on plain paper. She sold her quilts at the local craft fair, saving the money to fly and visit her children and grandchildren who lived across the country. I still find her an inspiration as I picture her sitting and sewing while she watches the seabirds swoop above the sea grass. A life so simple, calm, and peaceful.

Quilting is timeless. It travels with us through the seasons of our lives. If we start quilting when we are young, it's part of the early years of our marriage, the birth of our children, their school years, and those years when we must face that empty nest and retirement. Quilters are never bored. In our younger years we yearn for time to quilt, and in the later years we breathe a sigh of relief when that time—time for ourselves—finally becomes available. Our memories are tied up in our quilts. Like a song, our quilts bring back memories of where we were living, what was happening in our lives, our thoughts and emotions, even thoughts of those who now live only in our memories. Quilting is our pen, our paintbrush. In the last weeks of my friend's life as she was dying of cancer, she was still designing and quilting. She said it was the joy in her life and what she looked forward to each morning.

I have been quilting for almost 25 years now. I used to think that maybe one day I would get bored with the whole process and move on to another craft or hobby, but that hasn't happened yet and I don't think it ever will. Quilting is the gift I give myself every day. I love it! I still feel that rush of excitement when I think of a new design or find a really great piece of fabric. Then the process begins again. I still get excited about each step. This morning at 5:30 when the alarm went off and I dragged myself out of bed to head to the gym, I reminded myself that the reason I go there is to stay healthy because I want to live to be *really* old. Hey!—I've got a lot of fabric in my cupboards and so many quilts yet to make!

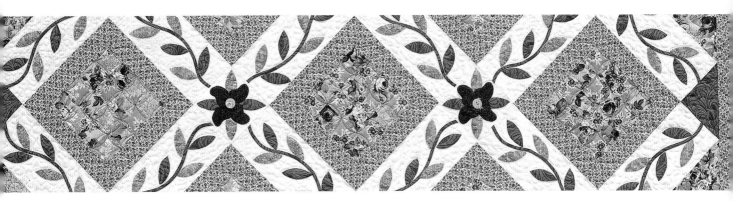

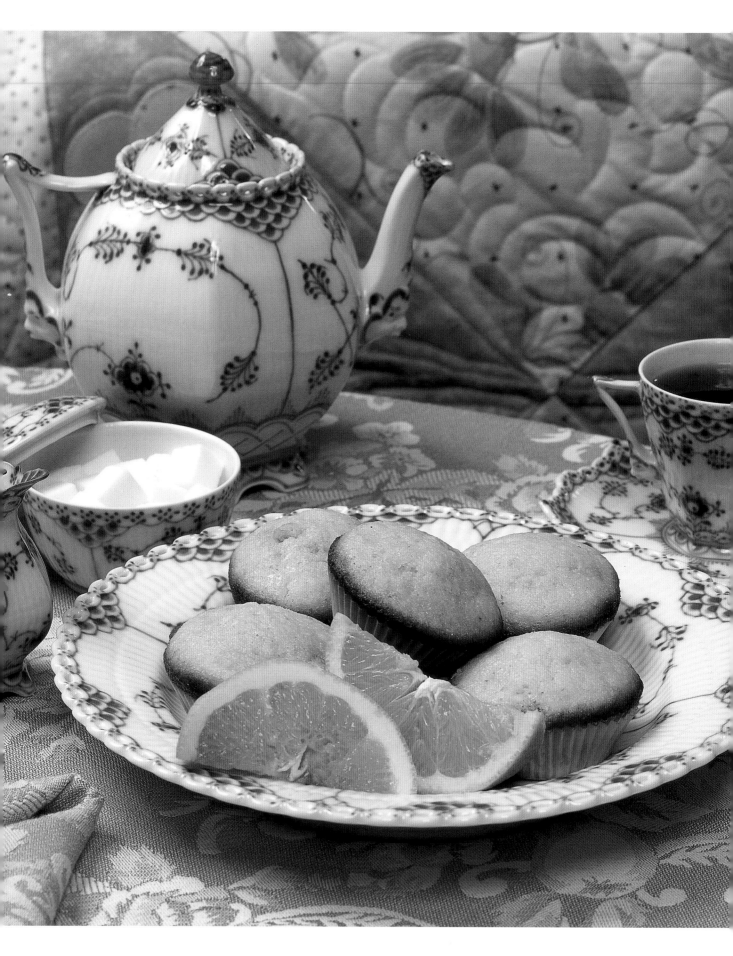

\mathscr{I}NTRODUCTION

I believe in magic. Not the sleight-of-hand kind, but *real magic*—that sparkle in your baby's eyes as he reaches out to you; big flowers that grow from tiny seeds; a beautiful rainbow after a summer shower; my husband's arm around my shoulders as we walk along; a newsy letter from my friend; sunrise on the beach; and a quiet cup of tea among my flowers, with the sun warming my skin, and the birds and bees moving lazily along, as content with the world as I am. It's these magical moments in life that are truly special. It's these special moments that we carry in our hearts, moments we pull out and relive when the daily stress and harried pace seem too much.

If you're a quilter, I know you believe in magic too. When quilting friends gather, you can feel the energy, the bond, that magic of sharing that flows freely. It surrounds us like a big hug and makes the day glow. And, of course, wherever quilters gather, there are usually treats and refreshments. At my house, I always serve tea and muffins. I love muffins. They remind me of quilts: lots of variety, but no matter the ingredients, always a delightful treat. They rise fast and easy with a homemade goodness that's like magic.

Over the years and throughout my travels I have collected muffin recipes, baked, and shared these delicious goodies with family and friends. Among the floral quilts you will find recipes that are my personal favorites. I hope you enjoy them, and I hope this book will be as much at home in your kitchen as in your sewing room. But most important, I hope it becomes part of a special moment in your life: you and friends in the garden, with tea and muffins, quilting and sharing. *You'll feel the magic!*

—*Cynthia*

The Perfect Cup of Tea

Since little-girl tea parties with playmates, tea has signified friendship and sharing. It means a time of contentment and peace, a time to slow down, relax, and savor. News shared over a cup of tea is always exciting and makes even a bad day better.

With a 5,000-year history, tea has considerable ritual, tradition, and mystery attached to its leaves. Tea names such as *Moroccan Mint*, *Russian Caravan*, *Jasmine Jazz*, *China Oolong*, *Almond Sunset*, and *English Breakfast* will have you experiencing adventures around the world from the comfort of your own home. There is a style and flavor of tea to suit every taste.

There are three kinds of tea. The difference between them lies in how they are processed. Black-tea leaves are fully fermented and have the highest level of caffeine; however, a cup of black tea still contains less caffeine than a cup of coffee. The leaves of green tea are not fermented at all. Green tea is very light in color and naturally low in caffeine. Oolong tea is partially fermented and is a compromise between black tea and green tea. Today the market also offers a wonderful selection of herbal teas as well as herbal infusions, both of which are caffeine-free.

You can purchase tea either in a loose form or in tea bags. If you choose to use loose tea, you will probably want to invest in a tea ball or tea infuser (a small metal or wire basket to hold the tea) to use in your cup or teapot. Otherwise it will be necessary to strain the tea before you serve it. If you're planning to serve tea to a group of friends, you may want to consider offering a selection of tea bags so that each person may choose the flavor and type that best suits her particular taste.

Pretty teacups or mugs and a charming teapot will add to the fun of sharing tea with friends. The selection is endless. Each gathering can feature a different theme or color selection, and with the addition of a bright table covering and napkins, you will definitely create a happy atmosphere.

To make a perfect pot of tea, fill your kettle with cold water. Cold water contains more oxygen and will prevent your tea from tasting flat or bitter. Fill the teapot with hot water to warm it. When the water in the kettle is almost to a boil, empty the teapot and add the tea ball or infuser filled with one teaspoon of loose tea for each cup you will be serving, plus one more teaspoon for the pot if you're making more than six cups of tea. If you're using tea bags, use one bag per cup. Pour boiling water into the teapot and let the tea steep for approximately three minutes. Remove the tea infuser or the tea bags to prevent the tea from becoming too strong.

Tea is wonderful served on its own but can also be served with milk, sugar, honey, a sprig of fresh mint, a slice of apple, orange, lemon, or a stick of cinnamon.

Once you have poured your first round of tea, keep your teapot warm with a tea cozy so that the second cup of tea will be as enjoyable as the first. To clean your teapot, just rinse with hot water, and you're ready for your next gathering of friends or serene tea-party-for-one in the garden.

Basic Steps to Making Great Muffins

Muffins are a wonderful treat to serve with tea. They are easy and take only minutes to make. Baking soda or baking powder will make the muffins rise nicely so there is no need for the lengthy process of working with yeast and kneading the dough. Muffins are also great served with soups and salads. Children love them because each muffin is a small individual portion just perfect for young eaters. Once you have tried these delicious treats, you will want to explore the variety of recipes and experiment with all the wonderful ingredients that are available.

All the muffins included in this book follow the same basic directions; simply refer to the individual recipes for specific ingredients and measurements.

- Preheat the oven to 350° F or 170° C.

- Fill 2¾" diameter muffin tins with paper liners or lightly grease the muffin tins with butter, margarine, or cooking spray. If you're making muffins for a party and want bite-sized finger food, you might want to try mini-muffin tins instead.

- In a large bowl, cream together butter, margarine, or oil (as specified by the recipe); sugar; and eggs. Add any remaining wet ingredients and blend well. Add all the dry ingredients and mix just until blended. The less you stir your batter, the better. Stirring too much will cause your muffins to be tough and create air pockets within the muffins. A light hand leads to the most delicious muffins! If you're adding nuts and/or fruit, add them last. Stir them in with only a couple of quick strokes.

- Divide the muffin batter evenly among the muffin cups, filling them approximately ¾ full.

- Bake the muffins for approximately 15 to 20 minutes or until a toothpick inserted into the center comes out clean. Baking time may vary with the size of the muffin tins you're using. Let the muffins cool in the tins for approximately five minutes, and then remove them to a wire rack to cool completely.

- Muffins are best eaten immediately. They are delicious plain but can also be served with butter, apple butter, jam, or cream cheese.

- Refrigerate any remaining muffins in an airtight container. Muffins also freeze well for later use.

CUTTINGS QUILT AND PILLOW

Embroider these sprightly flowers in a rainbow of colors. The old-fashioned designs are a perfect complement to the wide array of 1930s reproduction print fabrics used in this quilt and coordinating pillow.

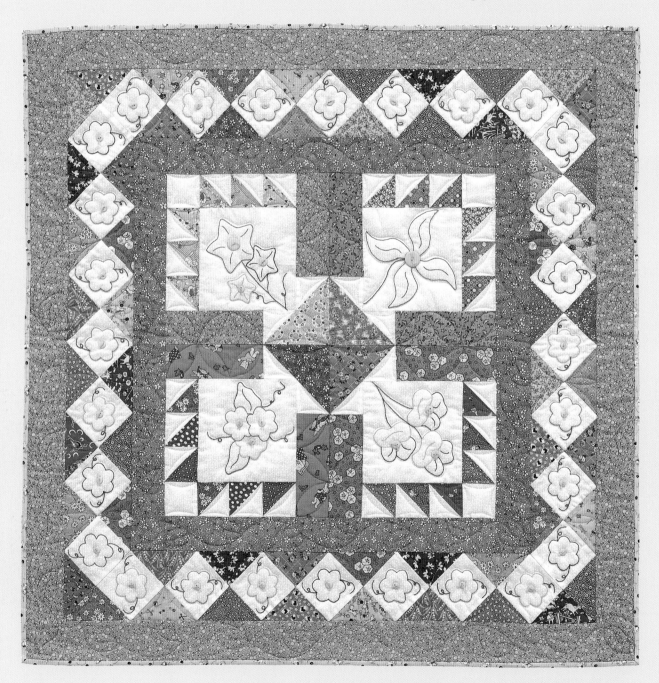

Finished quilt size: 37" x 37"

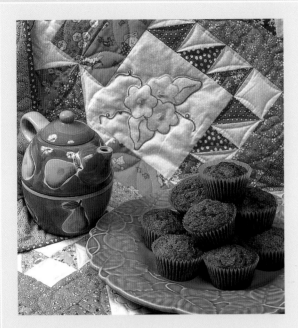

Zucchini Muffins

1 cup vegetable oil*

2 cups sugar

3 eggs

2 teaspoons vanilla

2 cups grated zucchini

3 cups all-purpose flour

1 teaspoon salt

1 teaspoon baking soda

½ teaspoon baking powder

2 teaspoons cinnamon

1 teaspoon ground cloves

½ cup chopped walnuts

For a low-fat version, use ¼ cup vegetable oil and ¾ cup applesauce.

Refer to baking directions detailed in "Basic Steps to Making Great Muffins" on page 11.

Yield: 24 muffins

Friends are coming

It's time for tea

We'll sit in the garden

With the birds and the bees

Materials for the Quilt and Pillow

Yardage is based on 42"-wide fabric.

⅞ yard of white-on-white print for center blocks, pieced border, and pillow block

¼ yard *each* of 3 different yellow prints for center block, pieced border, and pillow block

¼ yard *each* of 3 different purple prints for center block and pieced border

¼ yard *each* of 3 different blue prints for center block and pieced border

¼ yard *each* of 3 different green prints for center blocks

⅝ yard of green print A for center block, outer border, and pillow inner border

½ yard of yellow print A for quilt binding

¼ yard *each* of 2 different pink prints for center block and pieced border

⅜ yard of gold print for pillow outer border

⅜ yard of pink print A for center block, pieced border, and pillow binding

⅜ yard of green print B for inner border

(Continued on page 14.)

(Continued from page 13.)

1 yard of muslin for backing of quilted pillow top

2⅔ yards of fabric for backing of quilt and pillow

47" x 47" piece of batting for quilt

29" x 29" piece of batting for pillow

1 bag of fiberfill stuffing or 12" x 12" pillow form

1 skein *each* of 6-strand embroidery floss in pink, yellow, blue, purple, and green for flowers

Yellow buttons in the following diameters for flower centers: ⅞" (1 button), ¾" (1 button), ½" (4 buttons), and ⅜" (36 buttons)

Cutting for the Quilt

All measurements include ¼" seam allowances.

From the white-on-white print, cut:

- 4 squares, 6½" x 6½"
- 4 squares, 2½" x 2½"
- 16 squares, 2⅞" x 2⅞"; cut diagonally once to make 32 half-square triangles
- 28 squares, 3⅜" x 3⅜"

From the 3 different yellow prints, cut a *total* of:

- 3 squares, 2⅞" x 2⅞"; cut diagonally once to make 6 half-square triangles
- 4 squares, 5¼" x 5¼"; cut diagonally twice to make 16 quarter-square triangles (You will have 2 extras; use 1 for the pillow.)
- 1 square, 4⅞" x 4⅞"; cut diagonally once to make 2 half-square triangles (You will have 1 extra.)

From green print A and *each* of the 3 different green prints, cut:

- 2 rectangles, 2½" x 6½" (8 total)

From the remaining green print A, cut:

- 2 strips, 3" x approximately 34"
- 2 strips, 3" x approximately 39"

From the 3 different purple prints, cut a *total* of:

- 3 squares, 2⅞" x 2⅞"; cut diagonally once to make 6 half-square triangles
- 4 squares, 5¼" x 5¼"; cut diagonally twice to make 16 quarter-square triangles (You will have 2 extras; use both for the pillow.)
- 1 square, 4⅞" x 4⅞"; cut diagonally once to make 2 half-square triangles (You will have 1 extra.)

From the 3 different blue prints, cut a *total* of:

- 3 squares, 2⅞" x 2⅞"; cut diagonally once to make 6 half-square triangles
- 4 squares, 5¼" x 5¼"; cut diagonally twice to make 16 quarter-square triangles (You will have 2 extras; use 1 for the pillow.)
- 1 square, 4⅞" x 4⅞"; cut diagonally once to make 2 half-square triangles (You will have 1 extra.)

From pink print A and the 2 different pink prints, cut a *total* of:

- 3 squares, 2⅞" x 2⅞"; cut diagonally once to make 6 half-square triangles
- 4 squares, 5¼" x 5¼"; cut diagonally twice to make 16 quarter-square triangles (You will have 2 extras; use both for the pillow.)
- 1 square, 4⅞" x 4⅞"; cut diagonally once to make 2 half-square triangles (You will have 1 extra.)

From green print B, cut:

- 2 strips, 2½" x approximately 22"
- 2 strips, 2½" x approximately 26"

From yellow print A, cut:

- 4 strips, 2" x 42"

Assembling the Quilt

1. Using the patterns beginning on page 20, trace the flower designs onto the 6½" white-on-white squares for center blocks and the 3⅜" white-on-white squares for the pieced border. Stem stitch all the designs, referring to "Embroidery Stitches" on page 100 as needed.

2. Using the 2⅞" half-square triangles of white-on-white and yellow, make six half-square-triangle units.

Make 6.

3. Sew the half-square-triangle units from step 2 into two groups of three as shown.

4. Select one of the embroidered 6½" blocks and sew a unit from step 3 to the side. Press toward the triangles. Add a 2½" white-on-white square to the remaining unit from step 3 and sew it to the top of the block.

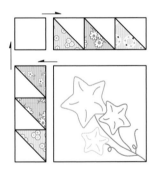

5. Sew a 2⅞" white-on-white half-square triangle to each of two green 2½" x 6½" rectangles as shown. Press.

6. Sew the units from step 5 to the two remaining sides of the block from step 4. Press.

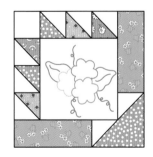

7. Sew a 4⅞" yellow half-square triangle to the lower-right corner of the block; press toward the triangle.

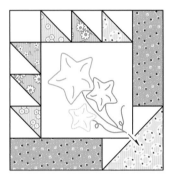

8. Repeat steps 2 through 7 using the pink, blue, and purple half-square triangles. Make a total of four blocks. The blocks should measure 10½" x 10½".

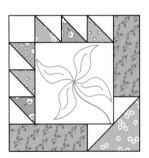

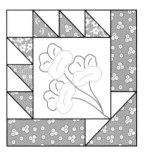

9. Sew the pieced blocks together to make the center square, pressing seams in opposite directions.

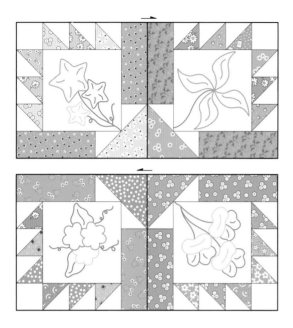

10. Refer to "Borders with Butted Corners" on page 105. For the inner border, measure the width of your quilt across the center. Cut the 2½" x 22" green print B strips to this measurement and sew them to the top and bottom of the quilt top. Press seams toward the border. To add the side borders, measure lengthwise through the center of your quilt, including the borders just added. Cut the 2½" x 26" green print B strips to this measurement and sew them to the sides of the quilt top. Press seams toward the border.

11. For the pieced border, make the four corner units first. Each corner unit will consist of two embroidered squares and four quarter-square triangles. Sew the pieces together as shown. Press seams in opposite directions or toward the darker fabric when possible.

Make 4.

12. Each pieced border will consist of five embroidered squares and 10 quarter-square triangles. Sew together as shown. Press seams in opposite directions or toward the darker fabric when possible. Make four border strips.

Make 4.

13. Sew the border strips to the quilt top. Press toward the inner border. Sew the four corner units to the quilt top. Press seams toward the inner border.

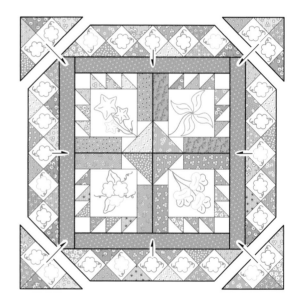

16

14. Measure the width and length of the quilt through the center. Cut and sew the strips of green print A to the quilt for the outer border as you did with the strips for the inner border.

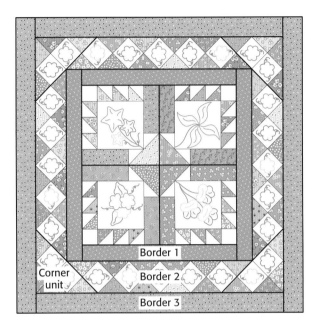

Finishing the Quilt

Refer to "Quilt Assembly and Finishing" beginning on page 105 for more details if needed.

1. Mark the quilting design on the quilt top if desired. See the quilting suggestion below.

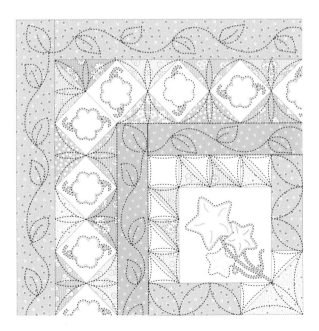

2. Layer the quilt top with batting and backing; baste.

3. Quilt by hand or by machine

4. Use the yellow strips to bind the edges of the quilt.

5. Sew the yellow buttons to the flower centers.

6. Add a label to the back of your quilt.

BUTTONS AS FLOWER CENTERS

Buttons make wonderful flower centers on this quilt. You may sew the buttons on in the traditional manner, or you may "tie" them on so that the thread tails are on top of the button to act as the flower stamens. To tie the button on, push the needle down through the buttonhole, leaving a 2" to 3" tail. Bring the needle back up through the opposite buttonhole and cut the thread 2" to 3" above the button. Tie the thread tails in a square knot to secure the button. Trim the threads so that they are ¼" to ½" long.

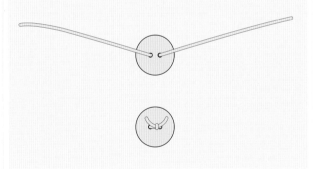

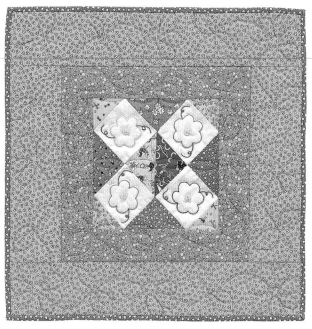

Finished pillow size: 19" x 19"

Cutting for the Pillow

All measurements include ¼" seam allowances.

From the white-on-white print, cut:
- 4 squares, 3⅜" x 3⅜"

From *each* of 2 of the different yellow prints, cut:
- 1 square, 2⅞" x 2⅞"; cut diagonally once to make a *total* of 4 half-square triangles

From green print A, cut:
- 2 strips, 2½" x 8½"
- 2 strips, 2½" x 12½"

From the gold print, cut:
- 2 strips, 4" x 12½"
- 2 strips, 4" x 19½"

From the muslin, cut:
- 1 piece, 29" x 29"

From the backing fabric, cut:
- 2 rectangles, 12" x 19½"

From pink print A, cut:
- 3 strips, 2" x 42"

Assembling the Pillow

1. Using the patterns beginning on page 20, trace the flower designs onto the 3⅜" white-on-white squares. Stem stitch the designs, referring to "Embroidery Stitches" on page 100 as needed.

2. The center block will consist of four embroidered squares, six quarter-square triangles left over from the quilt, and the four yellow half-square triangles. Sew the pieces together into diagonal rows as shown. Press. The block should measure 8½" x 8½".

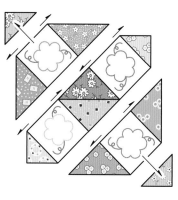

3. Sew the 2½" x 8½" green strips to the top and bottom of the block. Press seams toward the border. Sew the 2½" x 12½" green strips to the sides. Press.

4. Repeat step 3 to add the 4"-wide gold borders.

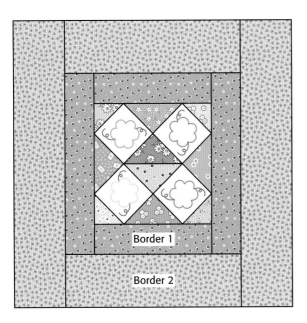

5. Mark the quilting design, referring to the illustration below, if desired. Layer the pillow top with batting and muslin; baste. Quilt on the marked lines.

6. After quilting, trim the excess backing and batting even with the pillow top.

7. Sew yellow buttons to the flower centers, referring to "Buttons as Flower Centers" on page 17.

8. Make a ¼" hem on one 19½" edge of each of the rectangles of backing fabric.

9. Place the pillow top right side down. Place the hemmed rectangles, right side up, over the pillow top so the hemmed ends overlap by about 3" and the outer edges are aligned. Pin in place.

10. Stitch in the ditch between the green and gold borders. Stitch through all layers.

11. Use the pink print strips to bind the edges of the pillow.

12. Stuff as desired with fiberfill or insert a purchased pillow form.

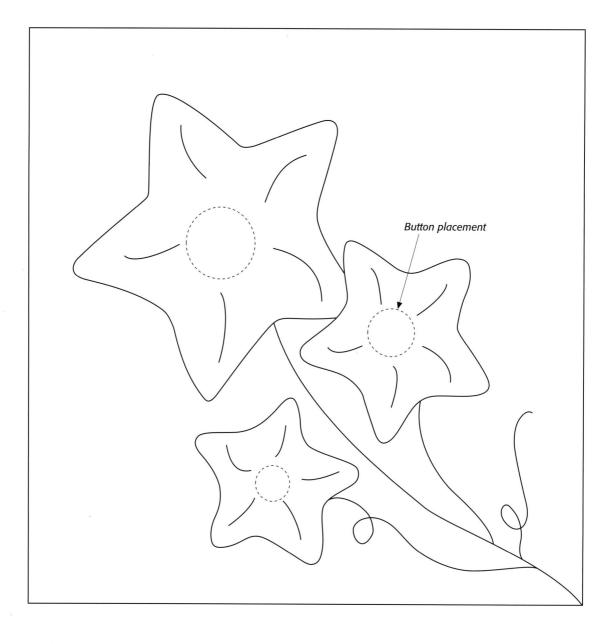

Button placement

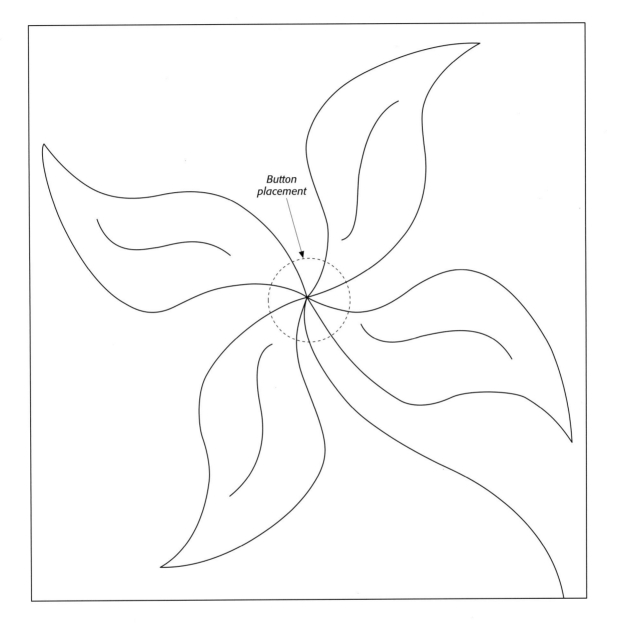

Button
placement

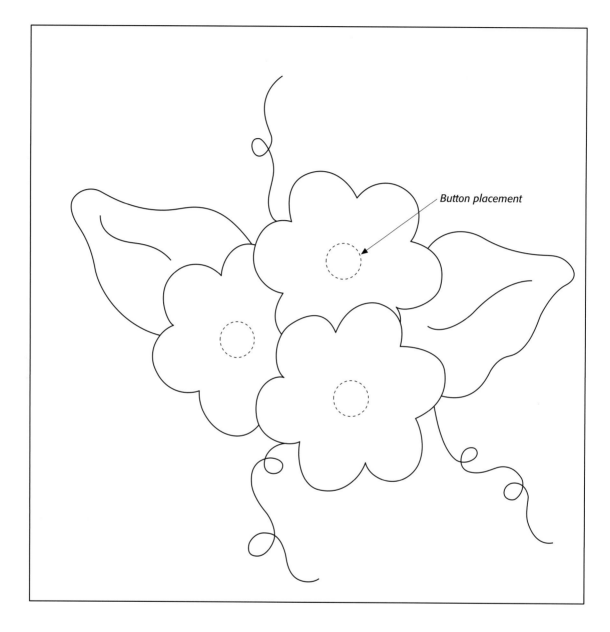

Button placement

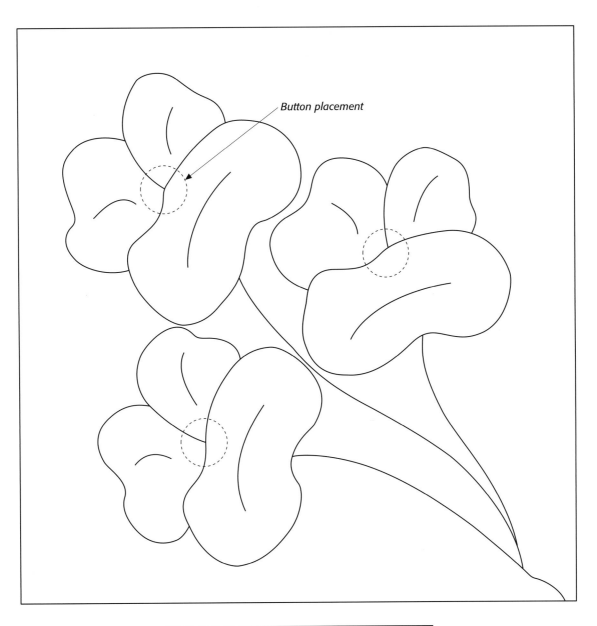

Button placement

Button placement

SUMMER AFTERNOON

Delicate curving appliqué in the border of this quilt delightfully frames the rambunctious flowers nestled in an old-fashioned, small-scale floral stripe.

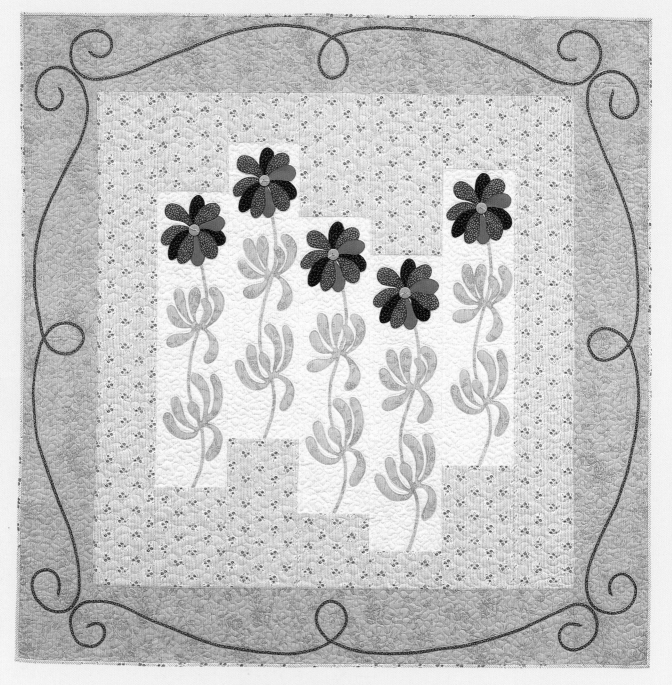

Finished quilt size: 52" x 52"

Fruity Muffins

¼ cup (½ stick) butter or margarine, melted

¾ cup packed brown sugar

1 large egg

1 teaspoon vanilla

1 cup all-purpose flour

½ cup quick-cooking oats

1 teaspoon baking powder

1 teaspoon ground cinnamon

¼ teaspoon salt

¾ cup diced, unpeeled tart apple (such as Granny Smith variety)

¾ cup fresh, frozen, or sweetened dried cranberries

¼ cup raisins

Refer to baking directions detailed in "Basic Steps to Making Great Muffins" on page 11.

Yield: 12 muffins

It's hot

It's humid

We're lazy as can be

We're cooling it down with ice cream and tea

Materials

Yardage is based on 42"-wide fabric.

2 yards of green print for flower stems, leaves, and border

1¾ yards of striped cream-and-lavender print for center and binding

1⅛ yards of white-on-cream print for appliqué background

½ yard of medium purple print for flower petals and border design

¼ yard of dark purple print for flower petals

⅛ yard of light purple print for flower petals

3½ yards of fabric for backing

62" x 62" piece of batting

5 green buttons, ⅞" diameter, for flower centers

Cutting

All measurements include ¼" seam allowances.

From the white-on-cream print, cut:

- 5 strips, 6½" x 24½"

(Continued on page 26.)

(Continued from page 25.)

From the green print, cut:

- 5 bias strips, ½" x 23"
- 2 strips, 6½" x approximately 42"
- 2 strips, 6½" x approximately 54"

From the striped cream-and-lavender print, cut:

- 1 piece, 3½" x 6½"
- 1 piece, 4½" x 6½"
- 2 squares, 6½" x 6½"
- 2 pieces, 6½" x 8½"
- 2 pieces, 6½" x 10½"
- 1 piece, 6½" x 12½"
- 1 piece, 6½" x 13½"
- 2 strips, 5½" x 40½"
- 6 strips, 2" x 42"*

Per flower
3 dark petals
2 light "
5 medium "

From the medium purple print, cut:

- ½"-wide bias strips to total 320"

**If you want to cut the striped binding on the bias, refer to "Making Bias Vines" on page 104 for instructions on cutting bias strips. Cut 2"-wide bias strips to total 226".*

Making the Center Strips

1. Refer to "Making Bias Vines" on page 104 to make ¼"-wide bias stems from the green print bias strips. Using the placement guide on page 27, position and pin the stems in place on the 6½" x 24½" white-on-cream background strips.

2. Choose your favorite appliqué method and make appliqué templates for the flower petals and leaves by enlarging and tracing the patterns on page 27. Refer to "Introduction to Appliqué" on page 98 for details as needed. Cut out the quantity indicated on the pattern for each shape.

3. Appliqué leaf 2 and a portion of leaf 3 to the background.

4. Appliqué the stems to the background.

5. Appliqué the remainder of leaf 3, leaf 1, and all flower petals to the background.

6. Sew the 6½"-wide cream-and-lavender pieces to the top and bottom of the appliquéd flower pieces, as shown in the quilt center layout. Press seams toward the darker fabric.

7. Sew the seven center strips together. Press the seams all in one direction.

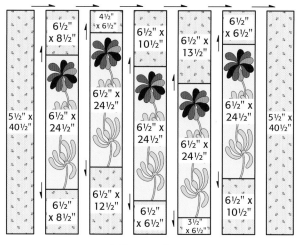

Quilt center layout

8. To add the top and bottom borders, refer to "Borders with Butted Corners" on page 105. Measure the width of your quilt across the center. Cut the 6½" x 42" green print strips to this measurement and sew them to the top and bottom of the quilt top. Press the seams toward the border. To add the side borders, measure lengthwise through the center of your quilt, including the borders just added. Cut the 6½" x 54" green print strips to this measurement and sew them to the sides of the quilt top. Press.

9. Referring to "Making Bias Vines" on page 104, make ¼"-wide bias stems from the medium purple bias strips. Use the diagram below as a guide to position the vines on the border and pin in place. Sew in position.

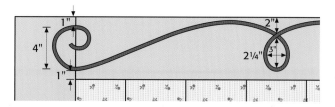

Finishing the Quilt

Refer to "Quilt Assembly and Finishing" beginning on page 105 for more details if needed.

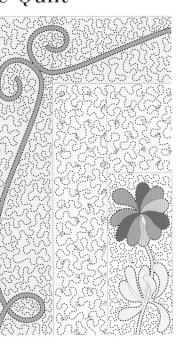

1. Mark the quilting design on the quilt top if desired. See the quilting suggestion at right.

2. Layer the quilt top with batting and backing; baste.

3. Quilt by hand or by machine.

4. Use the remaining cream-and-lavender strips to bind the edges of the quilt.

5. Sew the green buttons as flower centers, referring to "Buttons as Flower Centers" on page 17.

6. Add a label to the back of your quilt.

Appliqué Patterns and Placement Guide

Enlarge 200%.

Connect to the bottom of the pattern at right.

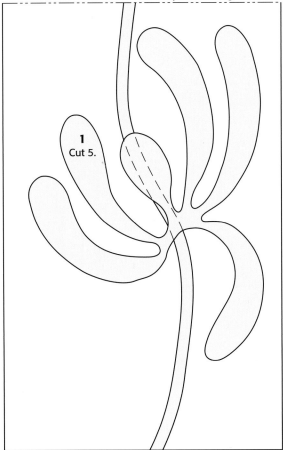

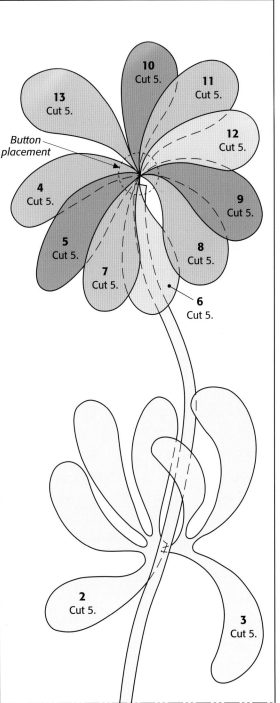

Connect to the top of the pattern at left.

Be Mine

Reds, reds, and more reds convey your love to that special someone in your life. Have fun finding just the right ones for this bright and cheerful quilt.

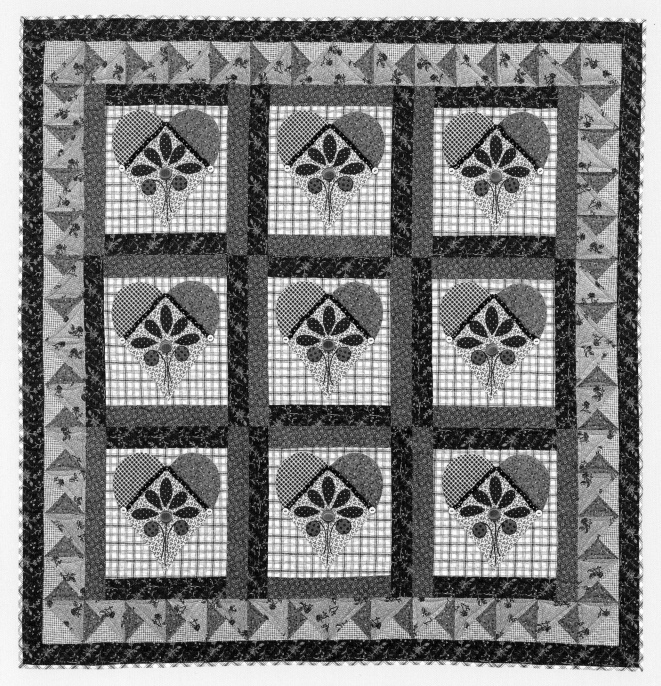

Finished quilt size: 45" x 45"

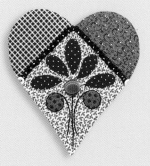

From 22 to 102

I'll always choose you!

Strawberry Coconut Muffins

½ cup vegetable oil

¾ cup sugar

2 eggs

2 cups all-purpose flour

½ teaspoon cinnamon

1 teaspoon baking powder

½ teaspoon baking soda

½ teaspoon ground nutmeg

½ teaspoon salt

1½ cups sliced strawberries

1 cup shredded, sweetened coconut

¾ cup chopped pecans or walnuts

Refer to baking directions detailed in "Basic Steps to Making Great Muffins" on page 11.

Yield: 12 muffins

Materials

Yardage is based on 42"-wide fabric.

1½ yards of red print A for sashings and outer border

1⅜ yards of cream-and-red plaid for block backgrounds and binding

⅝ yard of red print B for hearts and pieced border

½ yard of red print C for hearts

½ yard of red print D for sashings

½ yard of red print E for pieced border

⅜ yard of red print F for hearts

⅜ yard of red print G for pieced border

¼ yard of red print H for flower petals

⅛ yard of green print for leaves

3 yards of fabric for backing

55" x 55" piece of batting

3 yards of ¼"-wide red trim for hearts

9 green buttons, ⅞" diameter, for flower centers

18 white buttons, ½" diameter, and small white seed beads (a 10-gram package) for attaching trim on hearts

Green 6-strand embroidery floss for flower stems

Cutting

All measurements include ¼" seam allowances. Cut strips across the width of the fabric unless otherwise indicated.

From red print F, cut:
- 9 rectangles, 4" x 6"

From red print B, cut:
- 9 rectangles, 4" x 6"
- 12 squares, 4¼" x 4¼"; cut diagonally twice to make 48 quarter-square triangles

From red print C, cut:
- 9 squares, 6" x 6"

From the cream-and-red plaid, cut:
- 9 squares, 9½" x 9½"
- 5 strips, 2" x 42"*

From red print A, cut on the *lengthwise* grain:
- 10 strips, 2" x 9½"
- 8 strips, 2" x 12½"
- 2 strips, 2" x approximately 44"
- 2 strips, 2" x approximately 47"

From red print D, cut:
- 8 strips, 2" x 9½"
- 10 strips, 2" x 12½"

From red print E, cut:
- 26 squares, 3⅞" x 3⅞"; cut diagonally once to make 52 half-square triangles

From red print G, cut:
- 12 squares, 4¼" x 4¼"; cut diagonally twice to make 48 quarter-square triangles
- 2 squares, 3⅞" x 3⅞"; cut diagonally once to make 4 half-square triangles

If you want to cut the plaid binding on the bias, refer to "Making Bias Vines" on page 104 for instructions on cutting bias strips. Cut 2"-wide bias strips to total 198".

Assembling the Quilt

1. Sew together one rectangle from red print F, one rectangle from red print B, and one square from red print C as shown, with the rectangles overlapping. Leave the overlap area unsewn and press toward the darker fabrics. Make nine units.

Leave unsewn.

Make 9.

2. Choose your favorite appliqué method and make appliqué templates for the heart, flower petals, and leaves by enlarging and tracing the patterns on page 33. Refer to "Introduction to Appliqué" on page 98 for details as needed. Cut out the number of flower petals from red print H and the number of leaves from the green print according to the quantities indicated on the patterns.

3. Using the seam lines to position the designs properly, appliqué all flower petals and leaves to the nine sewn units.

4. Using two strands of green embroidery floss, stem stitch the stems. Refer to "Embroidery Stitches" on page 100 as needed.

5. Using the heart appliqué template, cut the appliquéd and embroidered units into nine heart shapes.

6. Appliqué the hearts to the plaid squares.

7. Use the white buttons and beads to sew the ¼"-wide red trim along the seam lines of each heart to hold it in place. First pin the

trim in position. Anchor the starting end of the trim by sewing one white button over the end to hold it in position. Continue to anchor the trim in place, sewing small beads approximately ¼" apart in a meandering fashion until you reach the end of the trim. Anchor the tail end of the trim by sewing one white button over it.

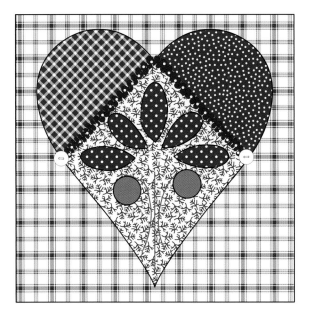

EASY BEADING

When sewing the beads in position, use a single thread and pass the needle through each bead twice before continuing. Knot off after every third or fourth bead. It is not necessary to cut your thread. Just continue sewing.

8. Sew the 2" x 9½" and 2" x 12½" red print sashing strips to the nine center blocks, alternating red prints A and D as shown. Press seams toward the sashing strips. (Seams pressed toward the light cream blocks would

show through and detract from the quilt's appearance.)

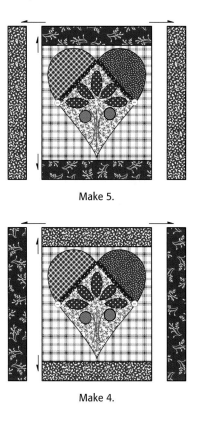

Make 5.

Make 4.

9. Arrange the blocks into three rows of three blocks each, alternating the sashing fabrics. Sew the blocks together into rows; press the seams in opposite directions from row to row. Sew the rows together.

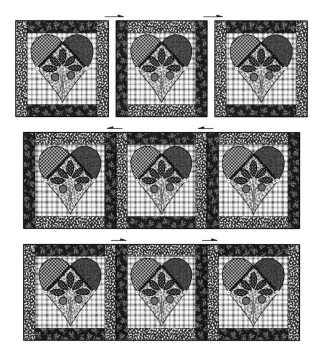

31

10. Sew 48 units for the pieced border by using the half-square and quarter-square triangles cut from the red prints. Press the seam joining the quarter-square triangles toward the darker fabric. Make 24 and 24 reversed as shown.

Make 24. Make 24 reversed.

11. Sew four half-square-triangle units as shown for the corners of the pieced border.

Make 4.

12. Construct the pieced borders using six units and six units reversed. Make four border strips.

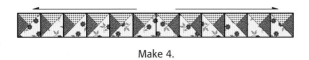

Make 4.

13. Sew border strips to the top and bottom of the quilt center. Press seams toward the quilt center. Sew a corner unit to the ends of each remaining strip. Sew the side borders to the quilt center. Press seams toward the quilt center.

14. To add the top and bottom outer-border strips, measure the width of your quilt across the center. Cut the 2" x 44" strips from red print A to this measurement and sew to the top and bottom of the quilt. Press seams toward the border. To add the side outer borders, measure lengthwise through the center of your quilt.

Cut the 2" x 47" strips from red print A to this measurement and sew to the sides of the quilt. Press seams toward the border.

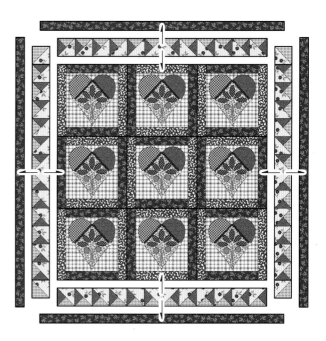

Finishing the Quilt

Refer to "Quilt Assembly and Finishing" beginning on page 105 for more details if needed.

1. Mark the quilting design on the quilt top if desired. See the quilting suggestion below.

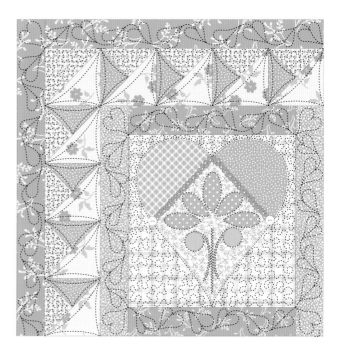

2. Layer the quilt top with batting and backing; baste.

3. Quilt by hand or by machine.

4. Use the plaid strips to bind the edges of the quilt.

5. Sew the green buttons to the flower centers. Refer to "Buttons as Flower Centers" on page 17.

6. Add a label to the back of your quilt.

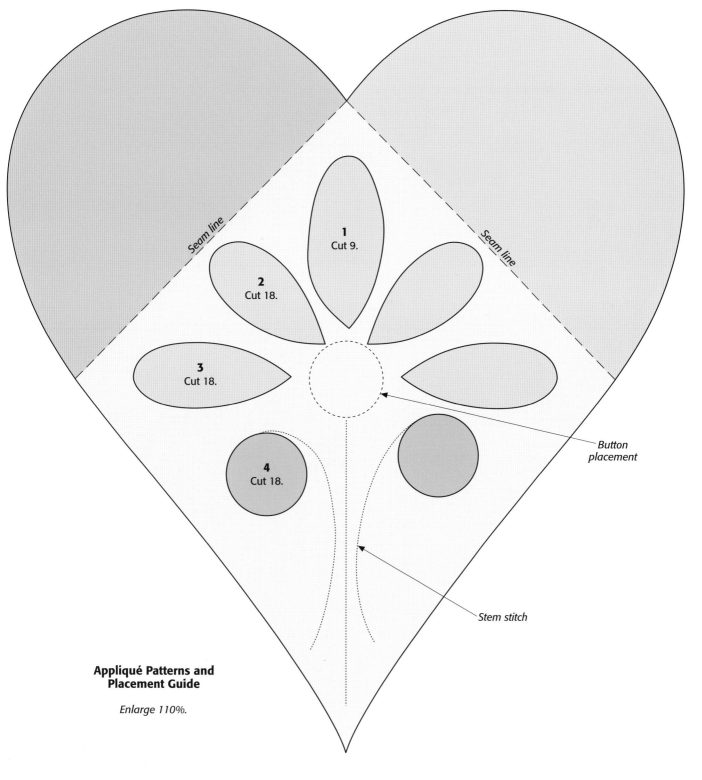

Seam line

Seam line

1
Cut 9.

2
Cut 18.

3
Cut 18.

4
Cut 18.

Button placement

Stem stitch

Appliqué Patterns and Placement Guide

Enlarge 110%.

COLORS OF LOVE

Jubilant red and yellow flowers with bright green leaves make a dramatic and heartfelt statement against the black-and-white checked background.

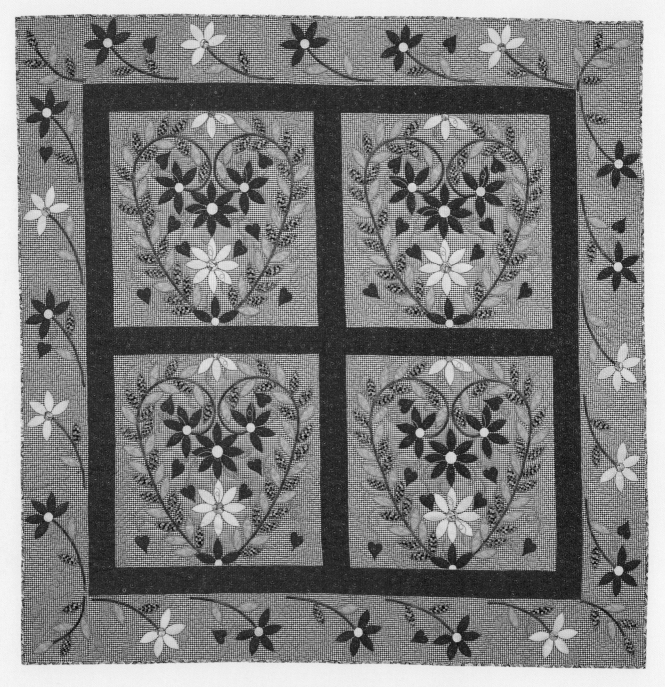

Finished quilt size: 69" x 69"

We meet at green

Our first "hello" might be mellow yellow

But our life together could be red hot

And all shades in between

Morning Glory Muffins

1 cup vegetable oil

3 eggs

1¼ cups sugar

2 teaspoons vanilla

2 cups all-purpose flour

2 teaspoons baking soda

2 teaspoons cinnamon

½ teaspoon salt

2 cups grated carrots

½ cup shredded, sweetened coconut

1 apple, peeled and chopped

½ cup raisins

½ cup chopped walnuts

Refer to baking directions detailed in "Basic Steps to Making Great Muffins" on page 11.

Yield: 24 muffins

Materials

Yardage is based on 42"-wide fabric.

5 yards of black-and-white checked fabric for background and border

1¾ yards of red print for sashing, hearts, and flower petals

⅝ yard *each* of green print B and green print C for leaves

¾ yard of green print A for bias stems

⅝ yard of green print D for flower centers and binding

½ yard of yellow print for flower petals and flower centers

4½ yards of fabric for backing

79" x 79" piece of batting

Green perle cotton size 8 embroidery thread for vines

Cutting

All measurements include ¼" seam allowances.

From green print A, cut:
- ½"-wide bias strips totaling 544"

From the black-and-white checked fabric, cut on the *lengthwise* grain:
- 4 squares, 24½" x 24½"
- 2 strips, 7½" x 55½"
- 2 strips, 7½" x 69½"

From the red print, cut on the *lengthwise* grain:
- 2 strips, 3½" x 23½"
- 3 strips, 3½" x 49½"
- 2 strips, 3½" x 55½"

From green print D, cut:
- 8 strips, 2" x 42"

Assembling the Quilt

1. Refer to "Making Bias Vines" on page 104 to make ¼"-wide bias stems from the green print bias strips. Using the placement guide on page 38, position and pin the stems in place on the checked background squares. Appliqué the stems to the background.

2. Choose your favorite appliqué method and make appliqué templates for the leaves, flowers, and hearts by tracing the patterns beginning on page 37. Cut out the quantity indicated on the pattern for each shape.

3. Appliqué all leaves, flower petals, flower centers, and hearts to the background.

4. Using the green perle cotton thread, stem stitch the trailing vines. Refer to "Embroidery Stitches" on page 100 as needed.

5. Trim the center blocks to 23½" x 23½".

6. Sew the blocks together with the sashing strips as shown. Press seams toward the sashing.

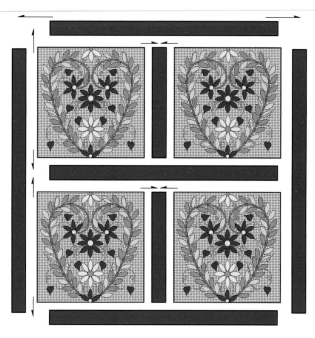

7. Divide the 7½" x 55½" checked top and bottom border strips into five 11" segments each. Mark the segments with a lightly pressed crease.

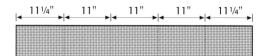

8. Appliqué the border, adding the bias stems for the flowers and leaves first. Then appliqué the leaves, flower petals, flower centers, and hearts. Stem stitch the trailing vines. Sew the top and bottom strips to the center unit. Press seams toward the sashing strips.

9. Divide the 7½" x 69½" checked side border strips into five 11" segments and two corner segments of 7¼" each. Referring to the project photo, reverse the placement of the flowers and appliqué the border motifs as in step 8. Appliqué the four corner designs. Sew the border strips to the sides of the center unit. Press seams toward the sashing strips.

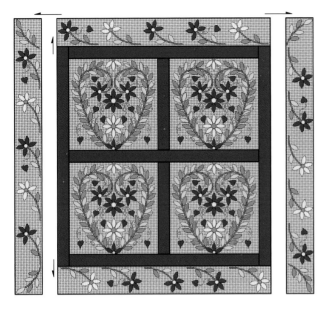

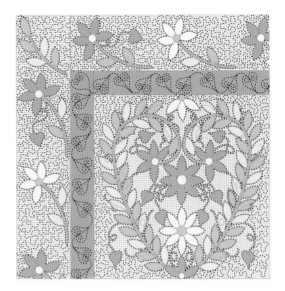

Finishing the Quilt

Refer to "Quilt Assembly and Finishing" beginning on page 105 for more details if needed.

1. Mark the quilting design on the quilt top if desired. See the quilting suggestion above right.

2. Layer the quilt top with batting and backing; baste.

3. Quilt by hand or by machine.

4. Use the green strips to bind the edges of the quilt.

5. Add a label to the back of your quilt.

**Border Corner
Appliqué Patterns
and Placement Guide**

1

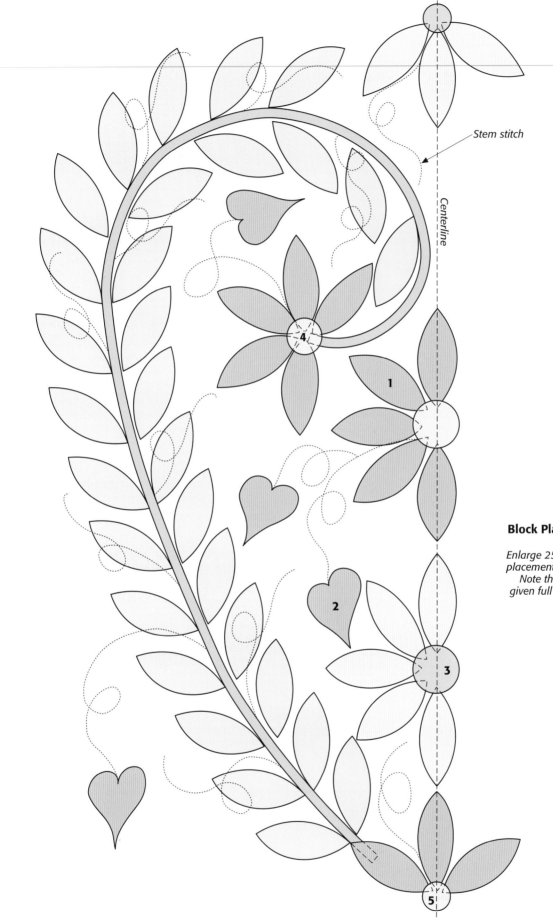

Stem stitch

Centerline

Block Placement Guide

Enlarge 250% for a full-size placement guide, if desired. Note that patterns are given full size on page 39.

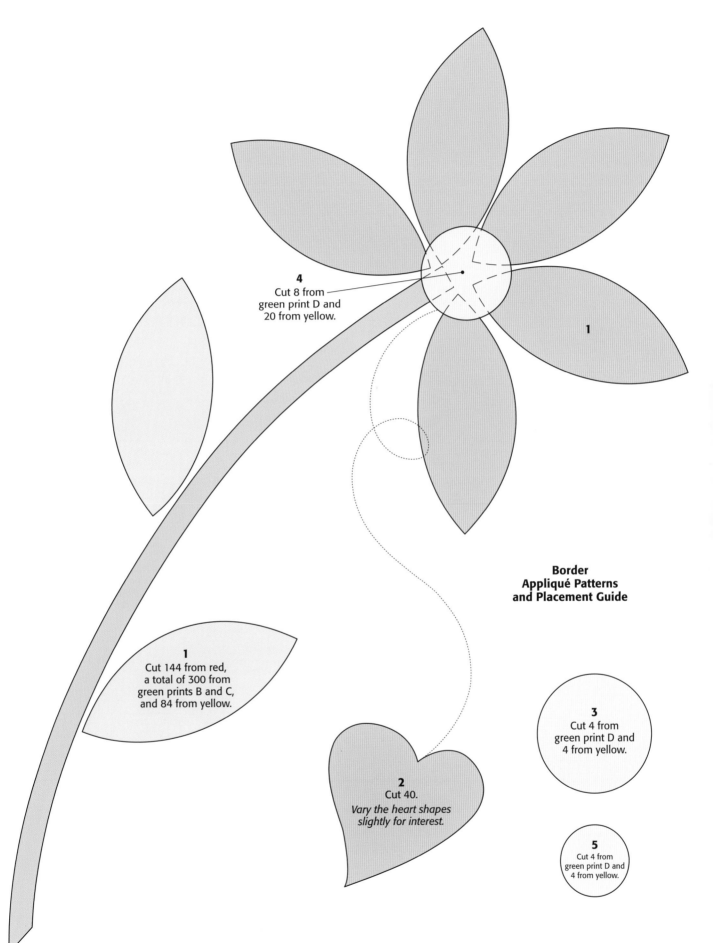

4
Cut 8 from
green print D and
20 from yellow.

1

**Border
Appliqué Patterns
and Placement Guide**

1
Cut 144 from red,
a total of 300 from
green prints B and C,
and 84 from yellow.

3
Cut 4 from
green print D and
4 from yellow.

2
Cut 40.
*Vary the heart shapes
slightly for interest.*

5
Cut 4 from
green print D and
4 from yellow.

SWEET TEA

These perky red flowers are right at home in the floral teacups.
Use old-fashioned fabrics in soft colors. Trailing vines appliquéd
in the borders add the crowning touch.

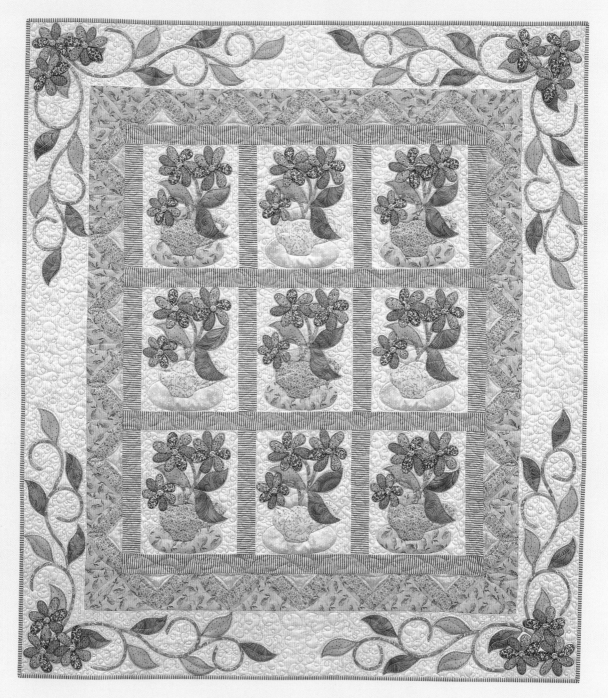

Finished quilt size: 47" x 53"

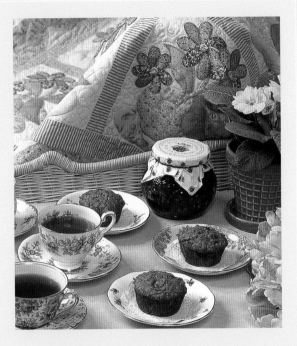

Cynthia's Banana Oatmeal Muffins

½ cup (1 stick) butter or margarine

½ cup sugar

2 eggs

1 ½ cups mashed ripe bananas

¼ cup skim milk

1 cup all-purpose flour

1 cup quick-cooking oats

1 teaspoon baking soda

½ teaspoon salt

½ teaspoon cinnamon

⅓ cup raisins

Refer to baking directions detailed in "Basic Steps to Making Great Muffins" on page 11.

Yield: 12 muffins

Time in the garden

Time for tea

Time together

Just you and me

Materials

Yardage is based on 42"-wide fabric.

2⅛ yards of yellow print A for block backgrounds and outer border

1 yard of green striped fabric for sashing and binding

⅜ yard *each* of 2 green prints for leaves

¼ yard *each* of 3 red prints for flower petals

⅝ yard of small-scale yellow-and-green print for teacups and pieced border

⅝ yard of medium-scale yellow-and-green print for saucers and pieced border

½ yard of green print for bias vines

⅜ yard of blue print for saucers and pieced border

¼ yard of yellow print B for teacups

3½ yards of fabric for backing

57" x 63" piece of batting

39 blue buttons, ½" diameter, for flower centers

Cutting

All measurements include ¼" seam allowances. Cut strips across the width of the fabric unless otherwise indicated.

From the green print for vines, cut:
- ½"-wide bias strips totaling 475"

From yellow print A, cut on the *lengthwise* grain:
- 9 rectangles, 9½" x 11½"
- 2 strips, 6" x approximately 38"
- 2 strips, 6" x approximately 55"

From the green striped fabric, cut:
- 12 strips, 2" x 10½"
- 4 strips, 2" x 30½"
- 6 strips, 2" x 42"

From the blue print, cut:
- 6 squares, 4¼" x 4¼"; cut diagonally twice to make 24 quarter-square triangles (You will have 2 extra.)

From the small-scale yellow-and-green print, cut:
- 22 pieces using template A (page 44)
- 22 pieces using template B (page 44)

From the medium-scale yellow-and-green print, cut:
- 7 squares, 7¼" x 7¼"; cut diagonally twice to make 28 quarter-square triangles (You will have 2 extra.)

Assembling the Quilt

1. Choose your favorite appliqué method and make appliqué templates for the teacups, leaves, and flower petals by tracing the patterns on page 45. Refer to "Introduction to Appliqué" on page 98 for details as needed. Cut out the quantity indicated on the pattern for each shape.

2. Refer to "Making Bias Vines" on page 104 to make ¼"-wide bias stems from the green print bias strips.

3. Appliqué the teacups, bias stems, leaves, and flower petals to the 9½" x 11½" yellow print rectangles. Appliqué in numerical order as indicated on the pattern.

4. Trim the center blocks to 8½" x 10½".

5. Arrange the blocks into three rows of three blocks each. Sew the sashing strips between the blocks to make the rows. Press seams toward the sashing strips. (Seams pressed toward the light center blocks would show through and detract from the quilt's appearance.)

6. Sew the sashing strips between the rows. Press seams toward the sashing strips.

7. Sew the units for the pieced border using the blue print triangles and the pieces cut using templates A and B. Press as shown. Make 22.

Make 22.

8. Sew four corner units using eight yellow-and-green print triangles.

Make 4.

9. Construct the top and bottom border strips using five units from step 7 and four yellow-and-green print triangles. Press seams toward the unpieced triangles. Sew the strips to the quilt center. Press seams toward the quilt center.

10. Construct the side border strips using six units from step 7 and five yellow-and-green print triangles. Press seams toward the unpieced triangles. Sew the strips to the quilt center. Press seams toward the quilt center.

11. Sew the four corner units to the quilt center, referring to the quilt diagram.

12. To add the outer border, refer to "Borders with Butted Corners" on page 105. Measure the width of your quilt across the center. Cut the 6" x 38" yellow print strips to this measurement and sew them to the top and bottom of the quilt top. Press seams toward the pieced border. To add the side borders, measure lengthwise through the center of your quilt, including the borders just added. Cut the 6" x 55" yellow print strips to this measurement and sew them to the sides of the quilt top. Press seams toward the pieced border.

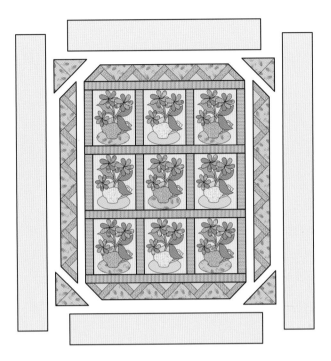

13. Refer to the border placement guide on page 44 and appliqué the bias vines, leaves, and corner flower petals to the outer border.

Finishing the Quilt

Refer to "Quilt Assembly and Finishing" beginning on page 105 for more details if needed.

1. Mark the quilting design on the quilt top if desired. See the quilting suggestion below.

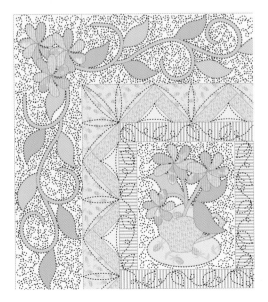

2. Layer the quilt top with batting and backing; baste.

3. Quilt by hand or by machine.

4. Use the remaining green striped strips to bind the edges of the quilt.

5. Sew the blue buttons to the flower centers. Refer to "Buttons as Flower Centers" on page 17.

6. Add a label to the back of your quilt.

Template Patterns

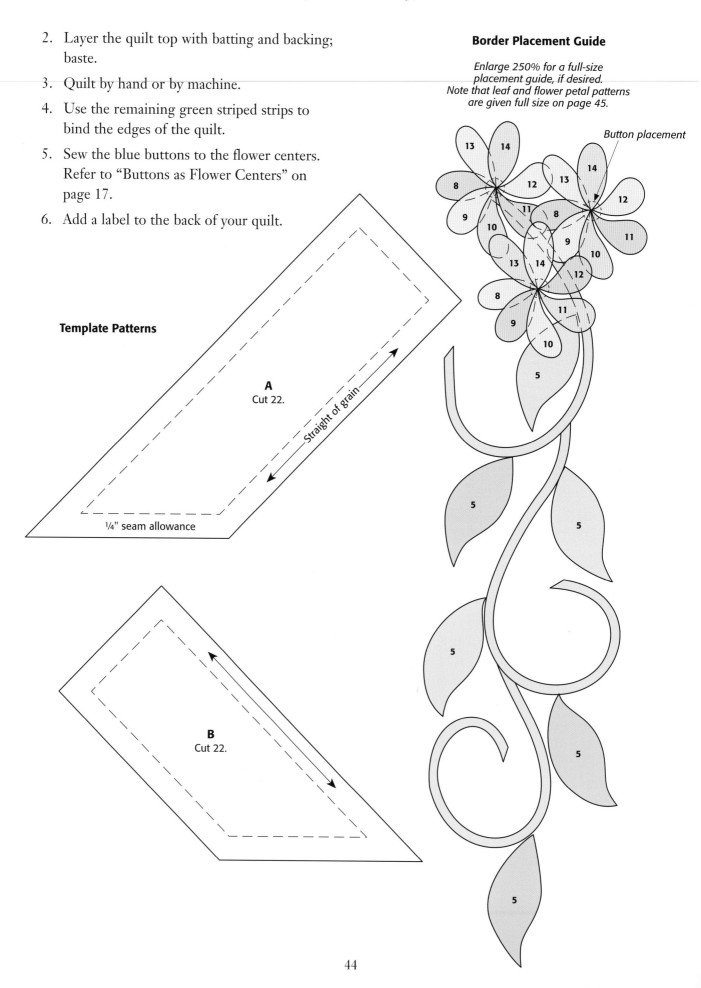

A
Cut 22.

Straight of grain

¼" seam allowance

B
Cut 22.

Border Placement Guide

Enlarge 250% for a full-size placement guide, if desired. Note that leaf and flower petal patterns are given full size on page 45.

Button placement

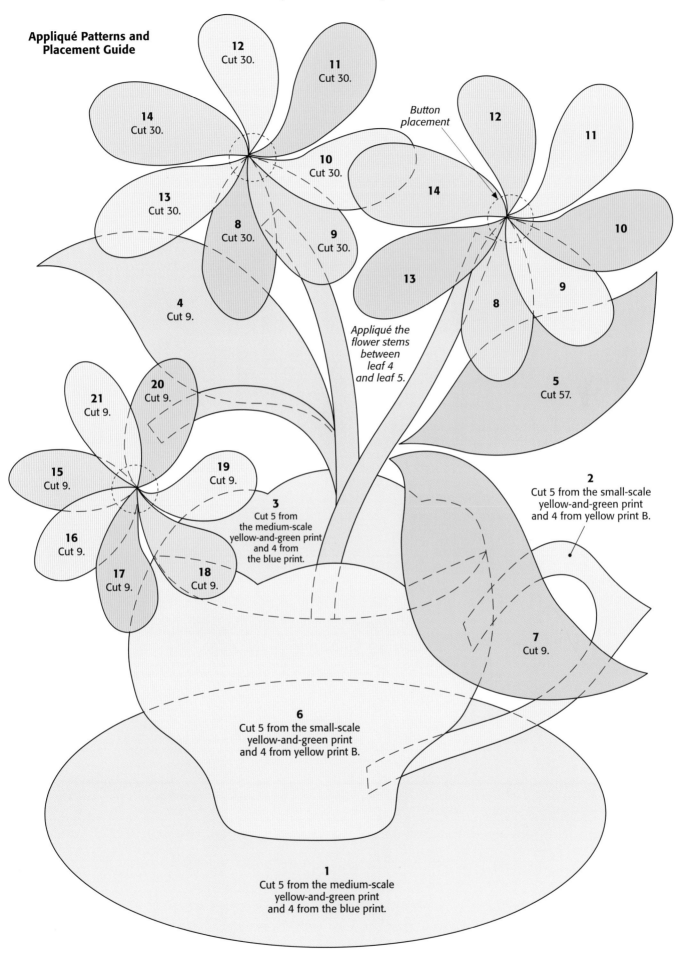

Appliqué Patterns and Placement Guide

12 Cut 30.

11 Cut 30.

14 Cut 30.

10 Cut 30.

Button placement

12

11

13 Cut 30.

8 Cut 30.

9 Cut 30.

14

10

13

9

8

4 Cut 9.

Appliqué the flower stems between leaf 4 and leaf 5.

5 Cut 57.

21 Cut 9.

20 Cut 9.

15 Cut 9.

19 Cut 9.

16 Cut 9.

17 Cut 9.

18 Cut 9.

3 Cut 5 from the medium-scale yellow-and-green print and 4 from the blue print.

2 Cut 5 from the small-scale yellow-and-green print and 4 from yellow print B.

7 Cut 9.

6 Cut 5 from the small-scale yellow-and-green print and 4 from yellow print B.

1 Cut 5 from the medium-scale yellow-and-green print and 4 from the blue print.

BUTTERFLY KISSES

*Think "spring" with butterflies softly kissing each flower in your garden.
Use bright coordinating threads to embellish the quick and easy fusible
appliqué; add extra charm with buttons as flower centers.*

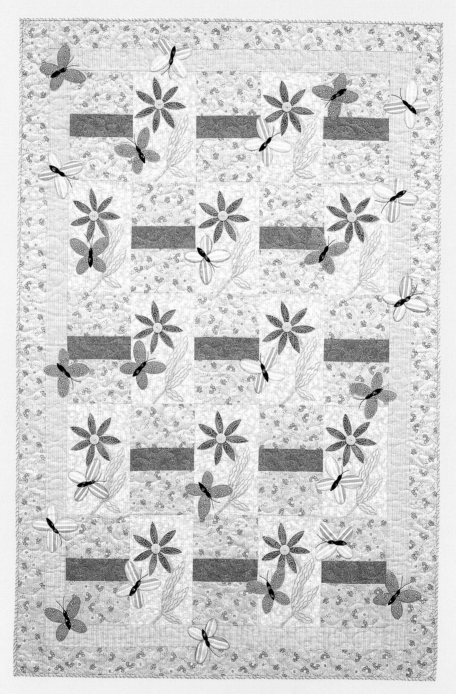

Finished quilt size: 40" x 60"

Mr. Butterfly was so freewheeling

Then he got that butterfly feeling

Now he's chosen a Butterfly Mrs.

And she showers him with butterfly kisses

Sailor's Cheddar Cheese Muffins

2 tablespoons sugar

1½ cups beer

2½ cups all-purpose flour

1 tablespoon baking powder

1½ teaspoons baking soda

1 teaspoon salt

1½ teaspoons dried dill

1 cup grated cheddar cheese

Refer to baking directions detailed in "Basic Steps to Making Great Muffins" on page 11.

Yield: 12 muffins

Materials

Yardage is based on 42"-wide fabric.

2 yards of green-and-purple floral for blocks and outer border

1¾ yards of yellow plaid for inner border

⅞ yard of yellow print for block background

¾ yard of green print A for leaves and binding

⅜ yard of purple print A for blocks

⅜ yard of purple print B for flower petals

⅜ yard of multicolored striped fabric for butterflies

¼ yard of multicolored print for butterflies

¼ yard of green print B for bias stems

¼ yard or scraps of black for butterflies

3 yards of fabric for backing

50" x 70" piece of batting

Black 6-strand embroidery floss for butterflies

12 yellow buttons, ⅞" diameter, for flower centers

Cutting

All measurements include ¼" seam allowances. Cut strips across the width of the fabric unless otherwise indicated.

From green print B, cut:
- ½"-wide bias strips to total 120"

From the yellow print, cut:
- 12 rectangles, 6½" x 10½"

From purple print A, cut:
- 13 rectangles, 2½" x 6½"

From the green-and-purple floral, cut on the *lengthwise* grain:
- 2 strips, 3½" x approximately 36"
- 2 strips, 3½" x approximately 62"
- 26 rectangles, 4½" x 6½"

From the yellow plaid, cut on the *lengthwise* grain:
- 2 strips, 2½" x approximately 32"
- 2 strips, 2½" x approximately 56"

From green print A, cut:
- 6 strips, 2" x 42"

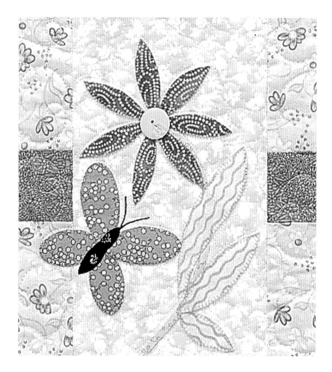

Assembling the Quilt

1. Refer to "Making Bias Vines" on page 104 to make ¼"-wide bias stems from the green print B bias strips. Using the placement guide on page 51, position and pin the stems in place on the yellow print rectangles. Appliqué the stems to the background.

2. Choose your favorite appliqué method and make appliqué templates for the leaves, flower petals, and butterflies by tracing the patterns on page 51. Cut out the quantity indicated on the pattern for each shape. Appliqué all leaves and flower petals to the 12 yellow print rectangles.

3. Assemble the alternate pieced blocks using the 2½" x 6½" rectangles of purple print A and the 4½" x 6½" rectangles of green-and-purple floral. Press seams toward the darker fabric. Make 13.

Make 13.

4. Arrange the blocks into five rows of five blocks each as shown. Sew the blocks together into rows and press seams in opposite directions from row to row. Sew the rows together and press the seams in one direction.

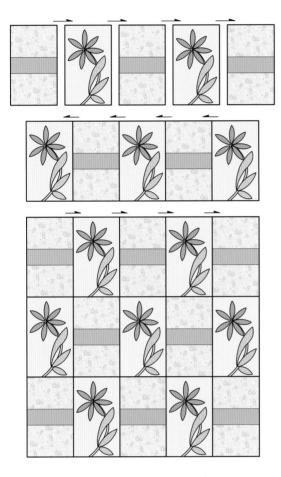

5. Appliqué butterflies randomly near each flower block; refer to the placement guide on page 51 and the project photo on page 46. The outer butterflies will be appliquéd after the borders are added.

6. Stem stitch butterfly antennae with one strand of black embroidery floss. Refer to "Embroidery Stitches" on page 100 as needed.

7. To add the inner border, measure the width of your quilt across the center. Cut the 2½" x 32" yellow plaid strips to this measurement and sew them to the top and bottom of the quilt top. Press seams toward the border. To add the side border, measure lengthwise through the center of your quilt, including the borders just added. Cut the 2½" x 56" yellow plaid strips to this measurement and sew them to the sides of the quilt top. Press. Refer to "Borders with Butted Corners" on page 105 as needed.

8. Repeat step 7 to add the green-and-purple floral strips for the outer border.

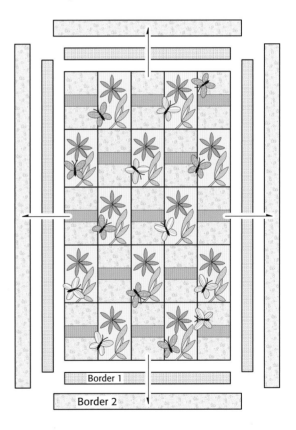

9. Randomly add more butterflies on your borders; use the photo on page 46 as a placement guide.

Finishing the Quilt

Refer to "Quilt Assembly and Finishing" beginning on page 105 for more details if needed.

1. Mark the quilting design on the quilt top if desired. See the quilting suggestion below.

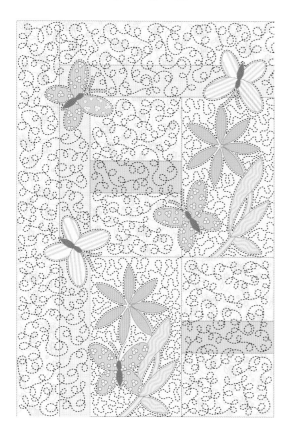

2. Layer the quilt top with batting and backing; baste.

3. Quilt by hand or by machine.

4. Use the green strips to bind the edges of the quilt.

5. Add a label to the back of your quilt.

6. Sew the yellow buttons to the flower centers. Refer to "Buttons as Flower Centers" on page 17.

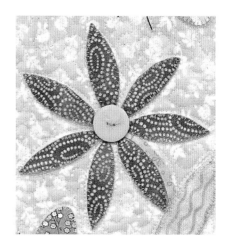

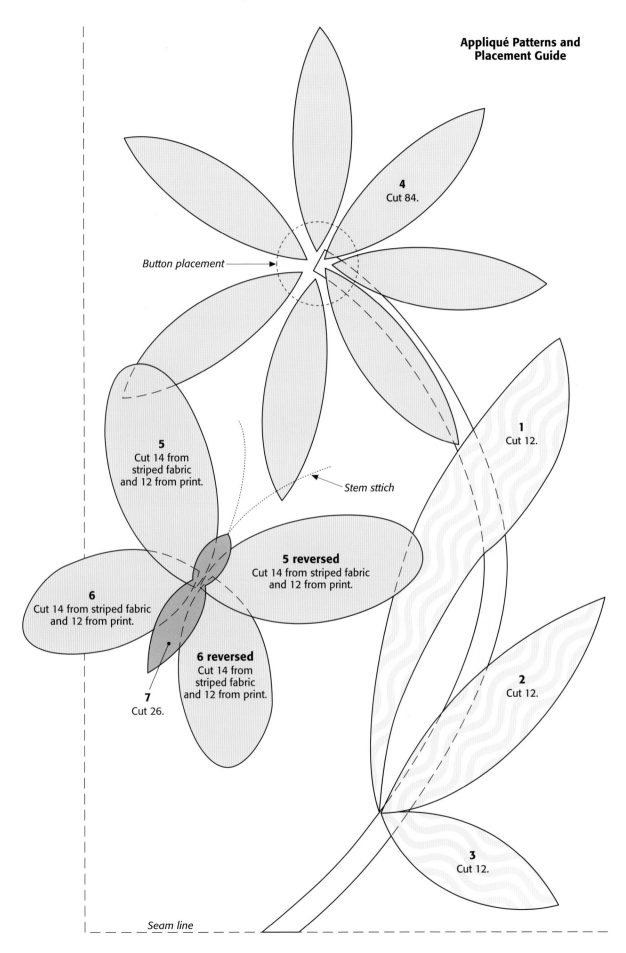

Appliqué Patterns and Placement Guide

4
Cut 84.

Button placement

5
Cut 14 from striped fabric and 12 from print.

Stem sttich

1
Cut 12.

5 reversed
Cut 14 from striped fabric and 12 from print.

6
Cut 14 from striped fabric and 12 from print.

6 reversed
Cut 14 from striped fabric and 12 from print.

7
Cut 26.

2
Cut 12.

3
Cut 12.

Seam line

51

Garden Smiles

This quilt is guaranteed to make you smile when you find the soft, warm, fuzzy hand-stitched flowers. Favorite buttons make perfect flower centers.

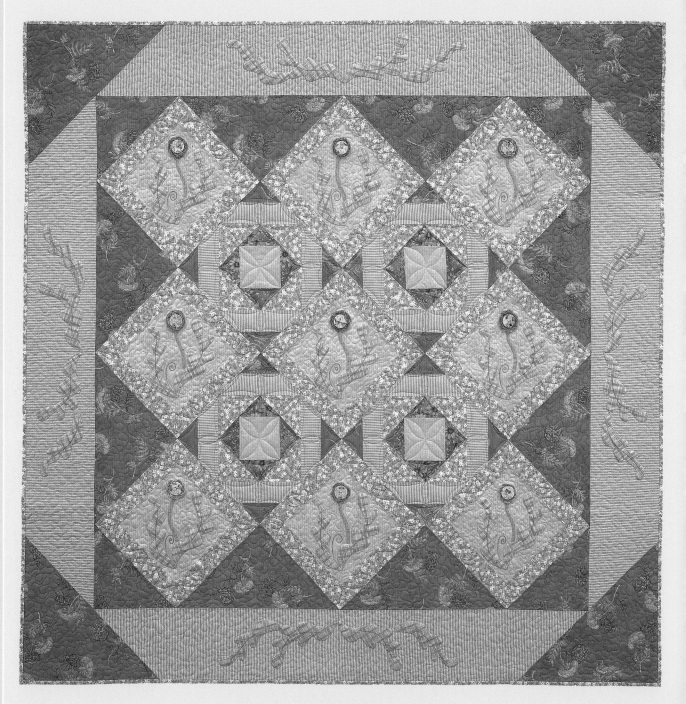

Finished quilt size: 54½" x 54½"

They're soft and fuzzy

So pretty and sweet

They make you smile

To pick them is a treat!

Blueberry Oatmeal Muffins

½ cup (1 stick) butter or margarine

½ cup sugar

2 eggs

1 cup plain yogurt, low-fat or regular

1 cup all-purpose flour

1 cup quick-cooking oats

1 teaspoon baking soda

½ teaspoon salt

1 teaspoon cinnamon

1 cup fresh or frozen blueberries

Refer to baking directions detailed in "Basic Steps to Making Great Muffins" on page 11.

Yield: 12 muffins

Materials

Yardage is based on 42"-wide fabric.

1¼ yards of blue striped fabric for pieced blocks and border

1¼ yards of blue print A for appliqué blocks, pieced blocks, and binding

1⅛ yards of blue print C for pieced blocks, setting triangles, and border triangles

⅞ yard of yellow print A for background of appliqué blocks

¾ yard of blue-and-yellow plaid for leaves

¼ yard of yellow print B for pieced blocks

¼ yard of blue print B for pieced blocks

¼ yard of green print for bias stems

3⅝ yards of fabric for backing

65" x 65" piece of batting

Blue perle cotton size 8 embroidery thread (plain, hand-dyed, or variegated blue) for flowers

Green 6-strand embroidery floss for tendrils and leaves

Nine floral buttons, 1⅛" diameter, for flower centers

Cutting

All measurements include ¼" seam allowances. Cut strips across the width of the fabric unless otherwise indicated.

From the green print, cut:
- ½"-wide bias strips to total 63"

From yellow print A, cut:
- 9 squares, 8½" x 8½"

From blue print A, cut:
- 18 strips, 2" x 7½"
- 18 strips, 2" x 10½"
- 8 squares, 4⅜" x 4⅜"; cut diagonally once to make 16 half-square triangles
- 6 strips, 2" x 42"

From blue print B, cut:
- 8 squares, 3⅜" x 3⅜"; cut diagonally once to make 16 half-square triangles

From yellow print B, cut:
- 4 squares, 4" x 4"

From the blue striped fabric, cut:
- 4 strips, 6½" x 43"*
- 16 pieces using the trapezoid template (page 56)

From blue print C, cut:
- 8 squares, 3⅜" x 3⅜"; cut diagonally once to make 16 half-square triangles
- 2 squares, 15½" x 15½"; cut diagonally twice to make 8 quarter-square triangles
- 2 squares, 8" x 8"; cut diagonally once to make 4 half-square triangles
- 2 squares, 12⅞" x 12⅞"; cut diagonally once to make 4 half-square triangles

**If the blue striped fabric is not wide enough after prewashing to cut 43" strips cross-grain, I suggest cutting the strips on the lengthwise grain to avoid piecing the borders. The quilt would look just as sweet with the border stripes running lengthwise.*

Assembling the Quilt

1. Refer to "Making Bias Vines" on page 104 to make ¼"-wide bias stems from the green print bias strips. Using the placement guide on page 57 as a guide, position and pin the stems in place on the 8½" yellow print background squares. Appliqué in position.

2. Choose your favorite appliqué method and make appliqué templates for the leaves by tracing the patterns on page 57. Refer to "Introduction to Appliqué" on page 98 for details as needed. Cut out the quantity indicated on the pattern for each shape.

3. Appliqué all leaves to the blocks.

4. Using two strands of the green embroidery floss, stem stitch tendrils and leaf veins. Refer to "Embroidery Stitches" on page 100 as needed.

5. Using the blue perle cotton thread, make three circles of loop stitches for the flowers. Begin with the outside circle and work inward. Refer to "Embroidery Stitches" as needed. (If you would like to make your flower heads larger, feel free to add more circles.)

6. Trim the appliqué blocks to 7½" x 7½".

7. Sew a 2" x 7½" blue print A strip to the top and bottom of each block. Sew the 2" x 10½" blue print A strips to the sides.

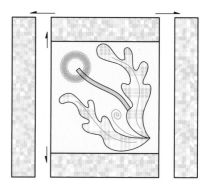

8. Sew two half-square triangles cut from blue print B to opposite sides of a yellow print B

square. Press toward the triangles. Add two triangles to the remaining sides and press.

9. Repeat step 8 to add the triangles cut from blue print A.

10. Sew the trapezoid pieces to the sides of the unit from step 9. Press toward the trapezoids.

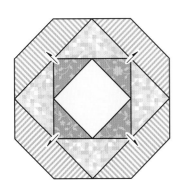

11. Add the 3⅜" half-square triangles of blue print C to the corners. Press toward the corners. Make four pieced blocks.

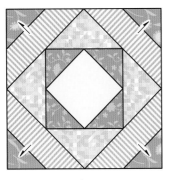

Make 4.

12. Assemble the quilt center in diagonal rows as shown. Press seams in opposite directions from row to row.

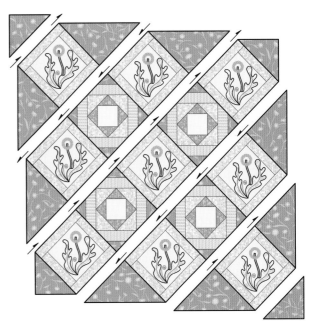

13. Appliqué four leaves to each of the 6½" x 43" blue striped border strips, referring to the border placement guide on page 57. Stem stitch the veins.

14. Trim the ends of the border strips to a 45° angle as shown.

15. Sew the four border strips to the quilt center. Press toward the borders or toward the darker fabric if seam allowances show through the borders.

16. Sew the 12⅞" half-square triangles of blue print C to the corners and press toward the triangles.

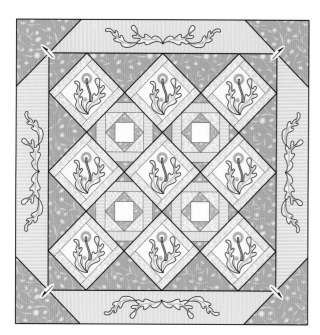

Finishing the Quilt

Refer to "Quilt Assembly and Finishing" beginning on page 105 for more details if needed.

1. Mark the quilting design on the quilt top if desired. See the quilting suggestion below.

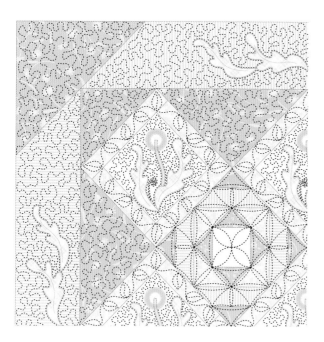

2. Layer the quilt top with batting and backing; baste.

3. Quilt by hand or by machine.

4. Use the remaining blue strips to bind the edges of the quilt.

5. Sew the floral buttons to the flower centers. Refer to "Buttons as Flower Centers" on page 17.

6. Add a label to the back of your quilt.

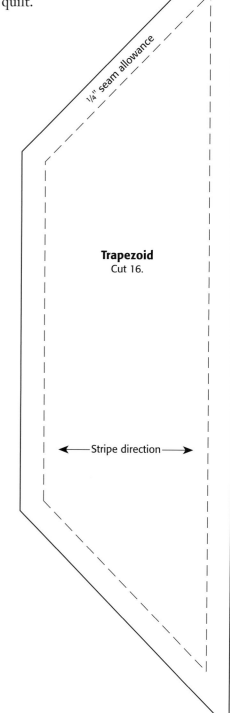

¼" seam allowance

Trapezoid
Cut 16.

← Stripe direction →

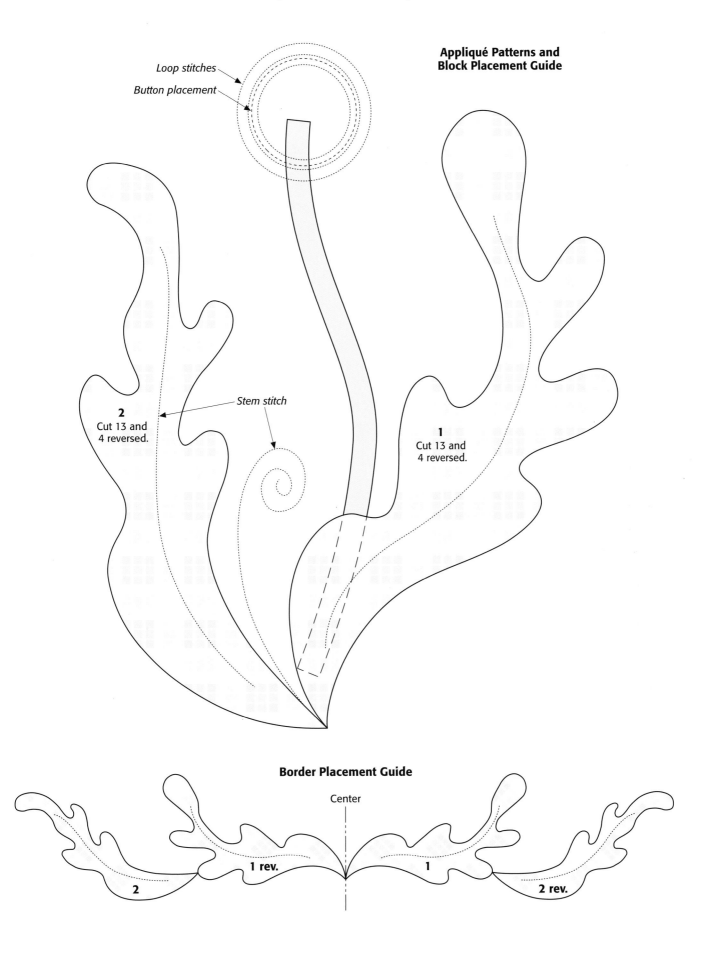

Appliqué Patterns and Block Placement Guide

Loop stitches

Button placement

Stem stitch

2
Cut 13 and
4 reversed.

1
Cut 13 and
4 reversed.

Border Placement Guide

Center

1 rev.

1

2

2 rev.

FRIENDSHIP OFFERINGS

The four flowers in each block do a little dance in eye-catching blue and red. Look for fun buttons to use as flower centers.

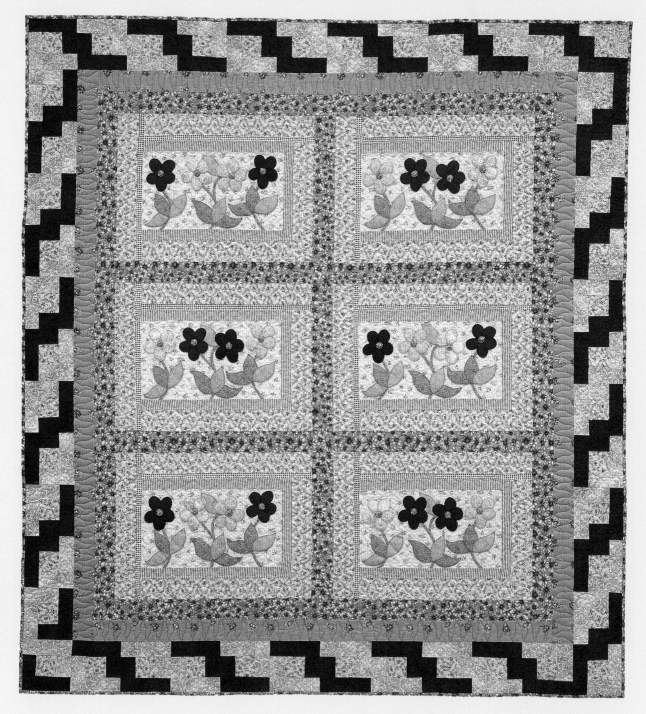

Finished quilt size: 60" x 65"

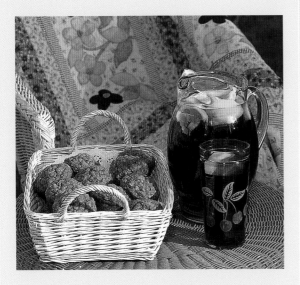

Applesauce Oatmeal Muffins

3 tablespoons vegetable oil

½ cup packed brown sugar

1 egg white

½ cup skim milk

1 cup applesauce

1½ cups quick-cooking oats

1¼ cups all-purpose flour

¾ teaspoon cinnamon

1 teaspoon baking soda

Topping:

¼ cup quick-cooking oatmeal

1 tablespoon packed brown sugar

⅛ teaspoon cinnamon

1 tablespoon butter or margarine, melted

Refer to baking directions detailed in "Basic Steps to Making Great Muffins" on page 11. Combine the topping ingredients and sprinkle over the tops of the muffins before baking.

Yield: 12 muffins

One 'cause you're fun

Two 'cause you're sweet

Three 'cause you're special

And four's just a treat

Materials

Yardage is based on 42"-wide fabric.

1¾ yards of green print A for border 2

1⅝ yards of red print A for sashings, border 1, and binding

1⅛ yards of beige floral for blocks and border 3

1 yard of red print B for flower petals and border 3

1 yard of blue print A for flower petals and border 3

1 yard of beige print for block backgrounds

⅜ yard *each* of green print B and green print C for bias stems and leaves

⅝ yard of green striped fabric for blocks

¼ yard of red-and-white checked fabric for blocks

¼ yard of blue print B for flower petals

¼ yard of red print C for flower petals

4 yards of fabric for backing

70" x 75" piece of batting

24 buttons, ⅝" diameter, for flower centers

Cutting

All measurements include ¼" seam allowances. Cut strips across the width of the fabric unless otherwise indicated.

From green prints B and C, cut a total of:
- ½"-wide bias strips to total 150"

From the beige print, cut:
- 6 rectangles, 8" x 14½"

From the green striped fabric, cut:
- 12 strips, 1½" x 14½"
- 6 pieces, 1½" x 10"*

From the beige floral, cut:
- 6 strips, 2½" x 12"
- 6 strips, 2½" x 14½"
- 6 strips, 2½" x 15½"
- 6 strips, 2½" x 17½"
- 46 squares, 2½" x 2½"

From the red-and-white checked fabric, cut:
- 6 strips, 1" x 17½"
- 6 strips, 1" x 14½"

From blue print A, cut:
- 92 pieces, 2" x 4"

From red print B, cut:
- 46 pieces, 2" x 2½"
- 46 pieces, 2" x 5½"

From red print A, cut on the *lengthwise* grain:
- 3 strips, 2½" x 14½"
- 4 strips, 2½" x 41½"
- 2 strips, 2½" x 50½"
- 7 strips, 2" x 42"

From green print A, cut on the *lengthwise* grain:
- 2 strips, 3" x 45½"
- 2 strips, 3" x 55½"

**Cut lengthwise if you want stripes to run vertically as in the quilt shown.*

Assembling the Quilt

1. Refer to "Making Bias Vines" on page 104 to make ¼"-wide bias stems from the green print bias strips. Using the placement guide on page 63, position and pin the stems in place on the beige print background rectangles. Appliqué in position.

2. Choose your favorite appliqué method and make appliqué templates for the leaves and flower petals by enlarging and tracing the patterns on page 63. Refer to "Introduction to Appliqué" on page 98 for details as needed. Cut out the quantity indicated on the pattern for each shape.

3. Appliqué all leaves and flower petals to the six background rectangles.

4. Beginning with the green striped pieces, add the borders to the block centers. Sew the 1½" x 14½" pieces to the top and bottom of each appliquéd block. Press seams toward the darker fabric. Add a 1½" x 10" piece to the side of each block. Press.

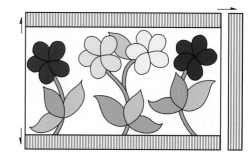

5. Sew 2½" x 15½" beige floral strip to the bottom and a 2½" x 12" beige floral strip to the side of each unit from step 4.

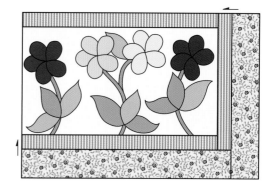

6. Add a 1" x 17½" checked strip to the top of each unit, followed by a 2½" x 17½" beige floral strip. Press. Add a 1" x 14½" checked strip and a 2½" x 14½" beige floral strip to the left side of each unit. Press. The blocks should measure 14½" x 20". Make 6.

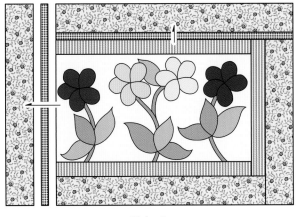

Make 6.

7. Assemble the blocks into three rows of two blocks each. Sew 2½" x 14½" red print A sashing strips to the center blocks as shown in the quilt layout at right to make the rows. Press seams toward the sashing. Sew 2½" x 41½" red print A sashing strips between the rows.

8. Sew the two remaining 2½" x 41½" strips of red print A to the top and bottom for border 1. Press seams toward the border strips. Sew the 2½" x 50½" red print A strips to the sides. Press.

9. Add the 3"-wide strips of green print A for border 2.

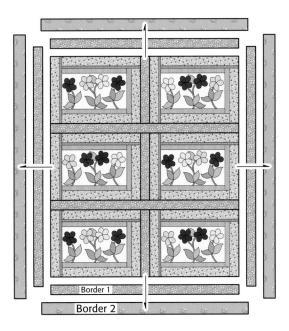

10. To make border 3, construct border blocks as shown. Press seams toward the darker fabric when possible. Begin with the 2½" beige floral squares. Add a 2" x 2½" red print B piece; then add a 2" x 4" blue print A piece in a clockwise manner. Add a second 2" x 4" blue piece followed by a 2" x 5½" red print B piece. The block should measure 5½" x 5 ½". Make 46.

Make 46.

11. Assemble the blocks into border strips as follows: 10 blocks each for the top and bottom borders, and 13 blocks for each side border. Rotate the blocks to alternate the position of the red and blue. Refer to the quilt diagram below and the photo on page 58 as placement guides. Press seams in one direction.

12. Sew the top and bottom border strips to the quilt. Press seams toward the green border. Sew the side border strips to the quilt. Press.

Finishing the Quilt

Refer to "Quilt Assembly and Finishing" beginning on page 105 for more details if needed.

1. Mark the quilting design on the quilt top if desired. See the quilting suggestion below.

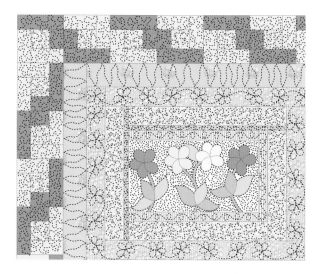

2. Piece the backing fabric horizontally. Layer the quilt top with batting and backing; baste.

3. Quilt by hand or by machine.

4. Use the remaining red strips to bind the edges of the quilt.

5. Sew buttons to the flower centers. Refer to "Buttons as Flower Centers" on page 17.

6. Add a label to the back of your quilt.

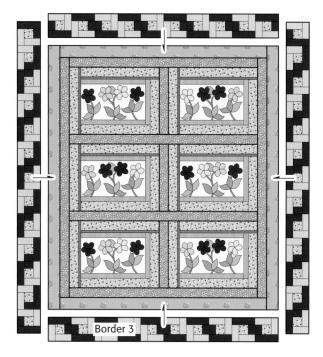

Border 3

Appliqué Patterns and Placement Guide

Enlarge 150%.

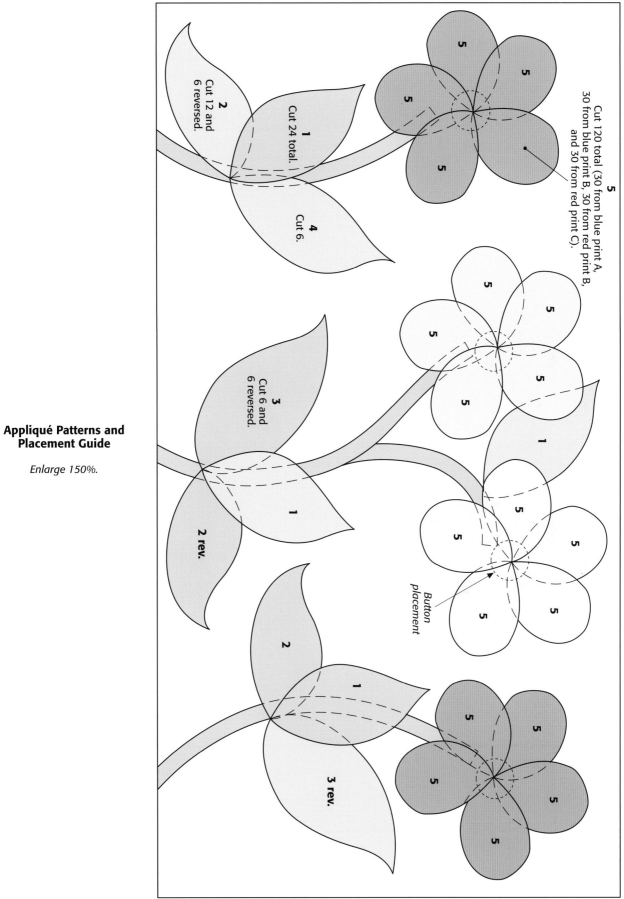

5
Cut 120 total (30 from blue print A, 30 from blue print B, 30 from red print B, and 30 from red print C).

2
Cut 12 and 6 reversed.

1
Cut 24 total.

4
Cut 6.

3
Cut 6 and 6 reversed.

1

2 rev.

1

5

Button placement

2

1

3 rev.

SWEET DREAMS

Old-fashioned florals make a striking backdrop for these flowing vines.
Use traditional hand appliqué or fusible appliqué and embellish
with shimmering threads and beloved buttons.

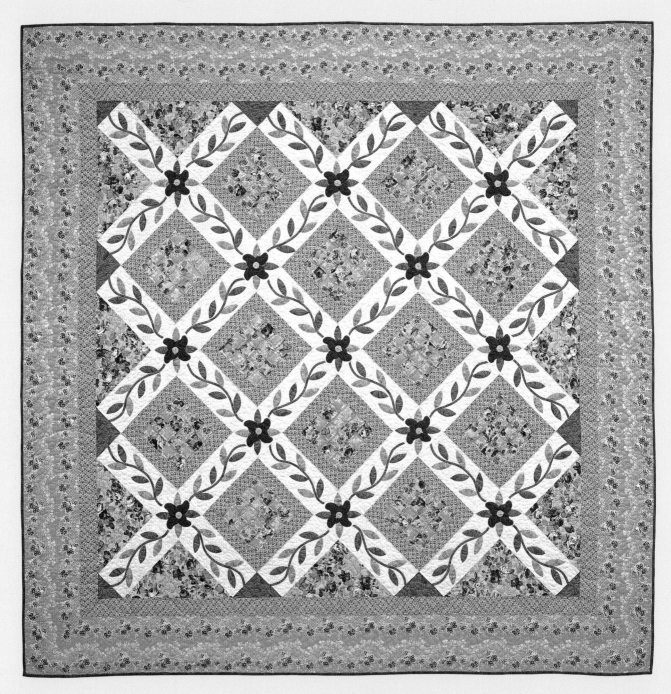

Finished quilt size: 71½" x 71½"

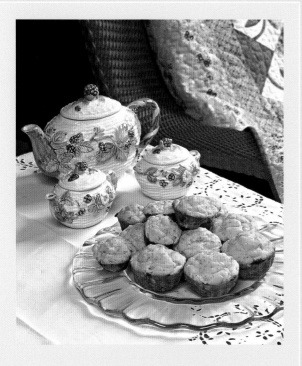

A look

A touch

A kiss

Our arms entwined

Sweet dreams, sweet love, sweet memories

Herb Cottage Cheese Muffins

¼ cup (½ stick) butter or margarine, melted

1 tablespoon sugar

1 egg

1 cup milk

¾ cup cottage cheese

2 cups all-purpose flour

2½ teaspoons baking powder

½ teaspoon baking soda

1 teaspoon dried dill

½ teaspoon salt

Refer to baking directions detailed in "Basic Steps to Making Great Muffins" on page 11.

Yield: 12 muffins

Materials

Yardage is based on 42"-wide fabric.

2⅜ yards of large-scale blue floral for blocks and outer border

2⅛ yards of small-scale red-and-beige print for blocks and inner border

1⅝ yards of white-on-cream print for sashing

1⅜ yards of beige floral for blocks and setting triangles

1¼ yards of green print A for leaves, bias stems, and sashing triangles

¾ yard of green print B for leaves

⅝ yard of red print A for binding

⅜ yard of red print B for flower petals

4⅝ yards of fabric for backing

82" x 82" piece of batting

13 buttons, ¾" diameter, for flower centers

Cutting

All measurements include ¼" seam allowances. Cut strips across the width of the fabric unless otherwise indicated.

From green print A, cut:

- ½"-wide bias strips to total 432"
- 2 squares, 3¾" x 3¾"; cut diagonally once to make 4 half-square triangles
- 2 squares, 7" x 7"; cut diagonally twice to make 8 quarter-square triangles

From the white-on-cream print, cut*:

- 36 strips, 4½" x 9½"
- 13 squares, 4½" x 4½"

From the beige floral, cut:

- 6 strips, 2" x 42"
- 3 squares, 14" x 14"; cut diagonally twice to make 12 quarter-square triangles

From the large-scale blue floral, cut on the *lengthwise* grain:

- 6 strips, 2" x 42"
- 4 strips, 6½" x approximately 77"**

From the small-scale red-and-beige print, cut on the *lengthwise* grain:

- 24 pieces, 2" x 6½"
- 24 pieces, 2" x 9½"
- 4 strips, 2½" x approximately 65"

From red print A, cut:

- 8 strips, 2" x 42"

**If you're working with fabric that tends to ravel, you may cut the dimensions of these pieces 1" larger and, after completing your appliqué, trim them to the required size.*

***If your print has a directional design or stripe, as mine does, you will need to cut the borders following the design so that each strip is the same. The pattern needs to meet at the mitered corners.*

Assembling the Quilt

1. Refer to "Making Bias Vines" on page 104 to make ¼"-wide bias stems from the green print A bias strips. Using the appliqué placement guide on page 69, position and pin the stems in place on the 4½" x 9½" white-on-cream sashing strips. Appliqué in position.

2. Choose your favorite appliqué method and make appliqué templates for the leaves and flower petals by tracing the patterns beginning on page 68. Refer to "Introduction to Appliqué" on page 98 for details as needed. Cut out the quantity indicated on the pattern for each shape.

3. Appliqué all the leaves and flower petals to the white-on-cream sashing strips and squares.

4. Sew the 2" x 42" strips of beige floral and blue floral together in groups of four to form strip sets. Make three sets and press seams in one direction. From the strip sets, cut a total of 48 segments, 2" wide, for the center blocks.

Make 3 strip sets.
Cut 48 segments.

5. Sew four of the segments from step 4 together as shown. Press the seams in one direction. Make 12 of these units.

Make 12.

6. Add the 2" x 6½" red-and-beige pieces to the top and bottom of a unit from step 5. Press. Add the 2" x 9½" pieces to the sides. Press. The block should measure 9½" x 9½". Make 12.

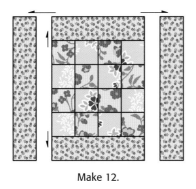

Make 12.

7. Assemble the appliqué strips, squares, pieced blocks, sashing triangles, and setting triangles into diagonal rows as shown. Sew the pieces together into rows and press seams toward the darker fabric when possible. Sew the rows together. Press the seams in one direction.

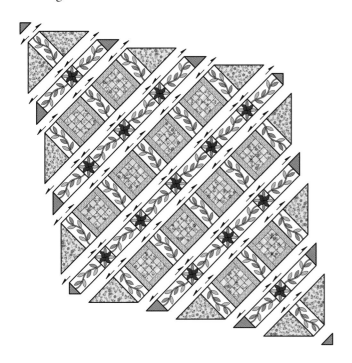

8. Find the center point of the top and bottom edges of the quilt as well as the center point of each side; mark with a pin. Using the remaining red-and-beige and blue floral strips, refer to "Borders with Mitered Corners" on page 106 to add the inner and outer borders with mitered corners.

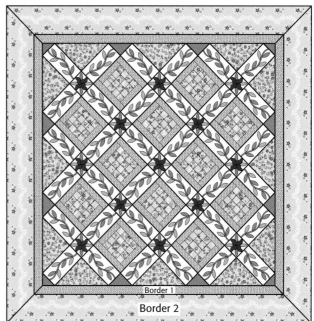

Finishing the Quilt

Refer to "Quilt Assembly and Finishing" beginning on page 105 for more details if needed.

1. Mark the quilting design on the quilt top if desired. See the quilting suggestion at right.

2. Layer the quilt top with batting and backing; baste.

3. Quilt by hand or by machine.

4. Use the red strips to bind the edges of the quilt.

5. Sew buttons to the flower centers. Refer to "Buttons as Flower Centers" on page 17.

6. Add a label to the back of your quilt.

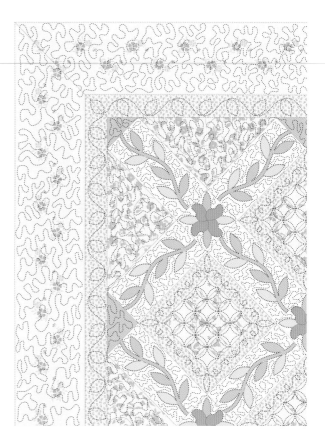

Appliqué Patterns and Placement Guide

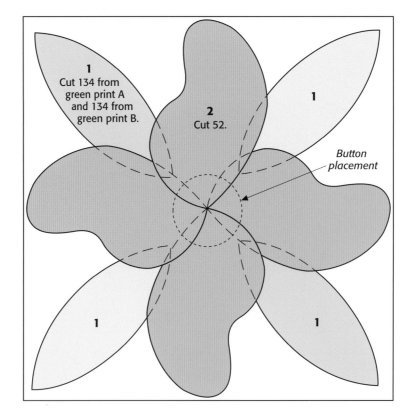

1
Cut 134 from green print A and 134 from green print B.

2
Cut 52.

1

Button placement

1

1

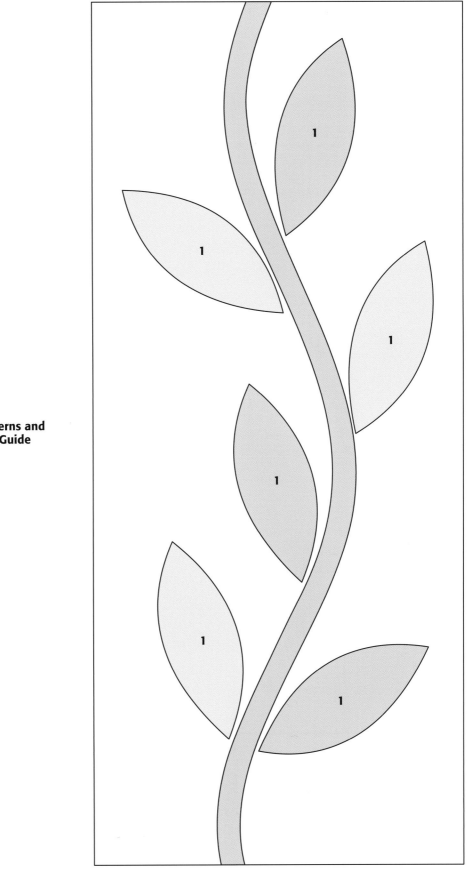

Appliqué Patterns and Placement Guide

M Is For . . .

This lovely wall hanging is a tribute to moms everywhere.
Combine charming 1930s reproduction prints with a large
old-fashioned floral print for a fitting medley.

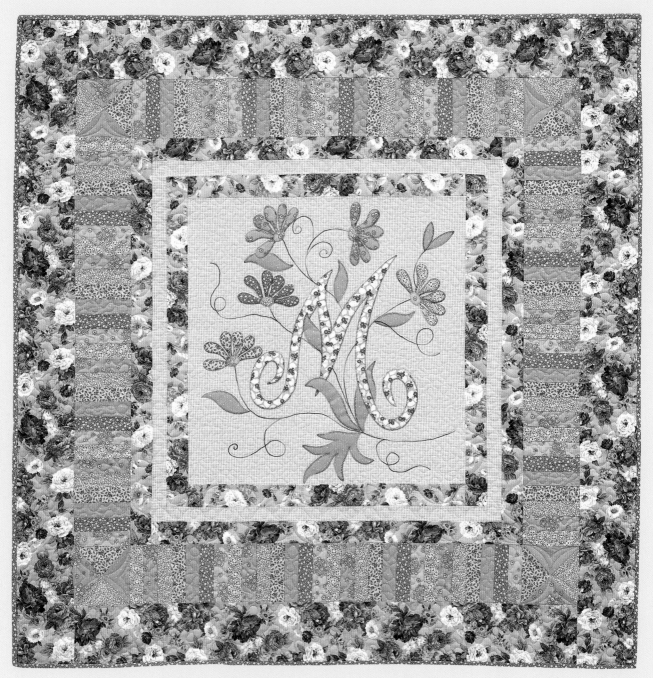

Finished quilt size: 44" x 44"

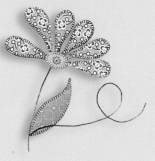

Mom's Banana Muffins

¼ cup (½ stick) butter or margarine

¾ cup sugar

1 egg

⅔ cup mashed bananas (2 to 3 medium bananas)

3 tablespoons sour milk (To make sour milk, add 1 teaspoon vinegar to 3 tablespoons milk.)

2 cups all-purpose flour

½ teaspoon baking powder

½ teaspoon baking soda

¼ teaspoon salt

½ cup chopped walnuts

Refer to baking directions detailed in "Basic Steps to Making Great Muffins" on page 11.

Yield: 12 muffins

Mom made muffins

Mom made tea

Mom grew flowers

Mom taught me

I make muffins

I make tea

I stitch flowers for loved ones to see

Materials

Yardage is based on 42"-wide fabric.

1½ yards of large-scale blue floral for borders 1, 3, and 5

⅞ yard of yellow plaid for background and border 2

⅝ yard of purple print for flower petals, pieced border 4, and binding

½ yard of blue-and-yellow floral print for appliqué letter *M*

⅜ yard of green print for leaves and pieced border 4

¼ yard *each* of 4 assorted prints for flower petals, flower centers, and pieced border 4

3 yards of fabric for backing

54" x 54" piece of batting

Hand-dyed green 6-strand embroidery floss for stems and vines

Cutting

All measurements include ¼" seam allowances. Cut strips across the width of the fabric unless otherwise indicated.

From the yellow plaid, cut:
- 1 square, 21" x 21"
- 2 strips, 1½" x 23½"
- 2 strips, 1½" x 25½"

From the large-scale blue floral, cut on the *lengthwise* grain:
- 2 strips, 2" x 20½"
- 2 strips, 2" x 23½"
- 2 strips, 2" x 25½"
- 2 strips, 2" x 28½"
- 2 strips, 4½" x approximately 38"
- 2 strips, 4½" x approximately 46"

From the purple print, cut:
- 5 strips, 2" x 42"

From the green print, the remainder of the purple print, and the 4 assorted prints, cut a *total* of:
- 112 rectangles, 1½" x 4½"
- 4 squares, 5¼" x 5¼"; cut diagonally twice to make 16 quarter-square triangles

Assembling the Quilt

1. Choose your favorite appliqué method and make appliqué templates for the letter *M*, flower petals, flower centers, and leaves by enlarging and tracing the patterns on page 74. Refer to "Introduction to Appliqué" on page 98 for details as needed. Cut out the quantity indicated on the pattern for each shape.

2. Appliqué the leaves, letter *M*, flower petals, and flower centers to the yellow plaid background square. Using two strands of green embroidery floss, stem stitch the stems and vines. Refer to "Embroidery Stitches" on page 100 as needed.

3. Trim the appliquéd block to 20½" x 20½", making sure your design is centered.

4. Sew the 2" x 20½" blue floral strips to the top and bottom of the appliquéd center block. Press seams toward the border. Sew the 2" x 23½" blue floral strips to the sides. Press.

5. Repeat step 4 to add the 1½"-wide yellow plaid strips (border 2) and the remaining 2"-wide blue floral strips (border 3).

6. Construct four pieced borders by using 28 of the 1½" x 4½" print rectangles for each. Press the seams in one direction.

Make 4.

7. Sew two pieced borders to opposite sides of the quilt top. Press seams toward the pieced border.

8. Piece four corner squares using the quarter-square triangles cut from the assorted prints.

Make 4.

9. Sew one unit made in step 8 to each end of the two remaining pieced border strips. Sew the strips to the top and bottom of the quilt top. Press seams toward the pieced border.

10. For border 5, measure across the center of your quilt. Cut the 4½" x 38" blue floral strips to this measurement and sew to the top and bottom of the quilt top. Press seams toward the outer border. To add the side strips, measure lengthwise through the center of your quilt. Cut the 4½" x 46" blue floral strips to this measurement. Sew to the sides of the quilt top. Press.

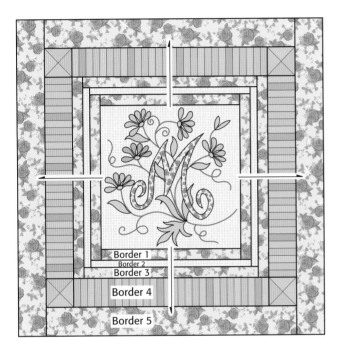

Border 1
Border 2
Border 3
Border 4
Border 5

Finishing the Quilt

Refer to "Quilt Assembly and Finishing" beginning on page 105 for more details if needed.

1. Mark the quilting design on the quilt top if desired. See the quilting suggestion below.

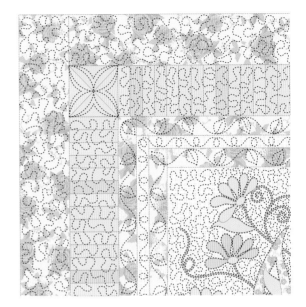

2. Layer the quilt top with batting and backing; baste.

3. Quilt by hand or by machine.

4. Use the purple strips to bind the edges of the quilt.

5. Add a label to the back of your quilt.

Appliqué Patterns and Placement Guide

Enlarge 250%.

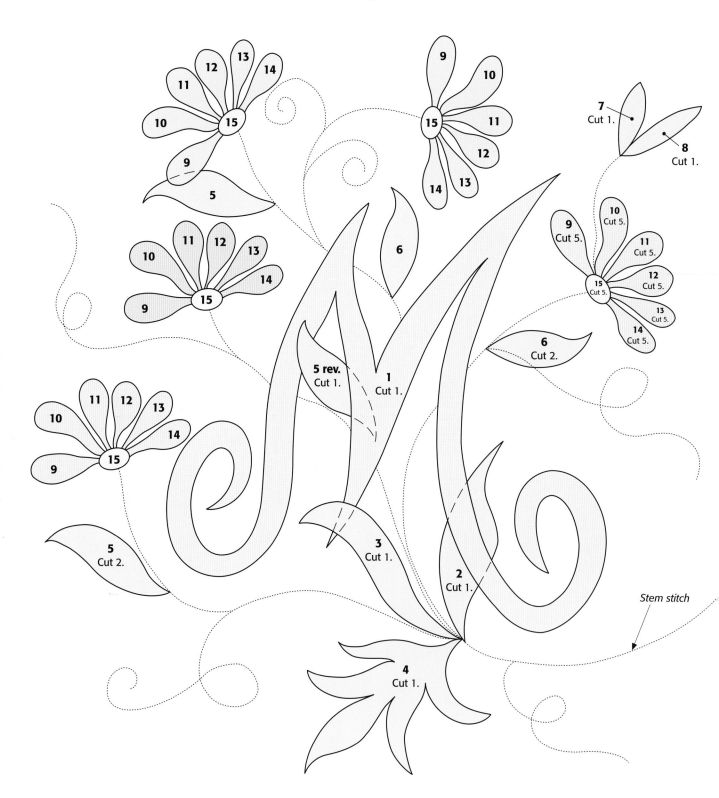

TRACES OF TIME

Wonderful fabrics with a soft, antique look, combined with traditional appliqué, instantly give this new quilt the feel of one from a bygone era.

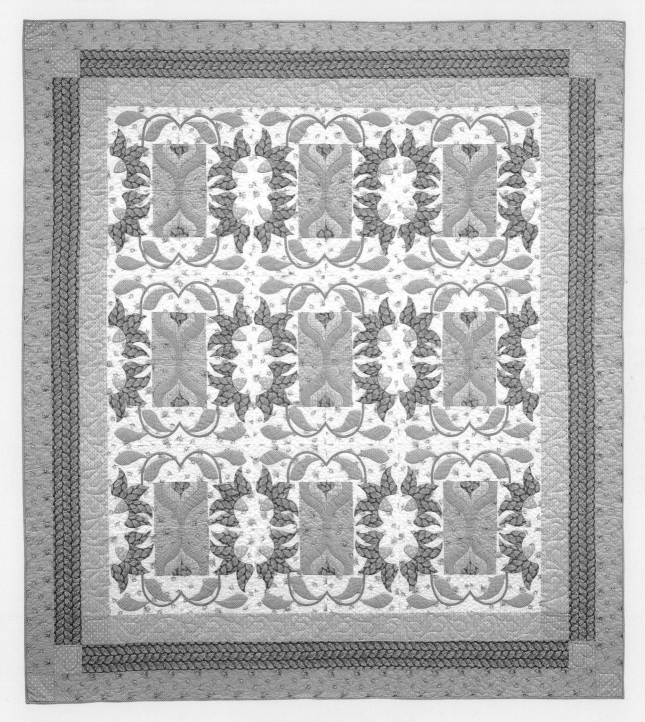

Finished quilt size: 66" x 72"

Thoughts of love, soft as a dove

Faded letters bound, with a ribbon found

The old locket has lost its glow

But the love . . . it still grows

Orange Nut Muffins

2 tablespoons vegetable oil

1 cup sugar

1 egg, beaten

¾ cup orange juice

2¼ cups all-purpose flour

2¼ teaspoons baking powder

¼ teaspoon baking soda

¾ teaspoon salt

1 tablespoon grated orange rind

¾ cup chopped walnuts

Refer to baking directions detailed in "Basic Steps to Making Great Muffins" on page 11.

Yield: 12 muffins

Materials

Yardage is based on 42"-wide fabric.

2⅜ yards of off-white print for background

2⅛ yards of dark peach print for flowers, small hearts, and border 2

2⅛ yards of peach print B for block backgrounds and border 3

2 yards of green plaid for leaves, large hearts, and binding

1¾ yards of peach print A for medium hearts and border 1

½ yard of green solid for bias stems

½ yard of green polka-dot print for flower centers and border corner squares

4⅝ yards of fabric for backing

76" x 82" piece of batting

Green perle cotton size 8 embroidery thread for flowers

Green 6-strand embroidery floss for flowers

Cutting

All measurements include ¼" seam allowances. Cut strips across the width of the fabric unless otherwise indicated.

From peach print B, cut on the *lengthwise* grain:

- 2 strips, 3½" x approximately 62"
- 2 strips, 3½" x approximately 68"
- 36 rectangles, 3½" x 5½"

From the off-white print, cut:

- 36 rectangles, 4½" x 8½"
- 36 squares, 5½" x 5½"

From the green solid, cut:

- ½"-wide bias strips to total 432"

From peach print A, cut on the *lengthwise* grain:

- 2 strips, 3½" x approximately 50"
- 2 strips, 3½" x approximately 56"

From the green polka-dot print, cut:

- 12 squares, 3½" x 3½"

From the dark peach print, cut on the *lengthwise* grain:

- 2 strips, 3½" x approximately 56"
- 2 strips, 3½" x approximately 62"

From the green plaid, cut:

- 8 strips, 2" x 42"

Assembling the Quilt

1. Choose your favorite appliqué method and make appliqué templates for the hearts, leaves, and flowers by enlarging and tracing the patterns on page 79. Refer to "Introduction to Appliqué" on page 98 for details as needed. Cut out the quantity indicated on the pattern for each shape.

2. Beginning with template 1, appliqué the shapes cut from templates 1, 2, 3, and 1, 2, 3 reversed to the 3½" x 5½" rectangles of peach print B. Refer to the illustrations below and the pattern on page 79. Make 18 and 18 reversed.

Make 18 and 18 reversed.

3. Sew an off-white square to the left side of 18 units from step 2. Repeat to sew an off-white square to the right side of the 18 reversed units. Press toward the appliquéd units.

Make 18 and 18 reversed.

4. Add an off-white rectangle to the top of each unit from step 3 to make 36 center blocks: 18 and 18 reversed. Press toward the top rectangle. The blocks should measure 8½" x 9½".

Make 18 and 18 reversed.

5. Referring to "Making Bias Vines" on page 104, make ¼"-wide bias stems from the ½"-wide green solid bias strips. Using the placement guide on page 79, position and pin the stems in place on the background. Appliqué in position. Make 18 and 18 reversed.

6. Appliqué the leaves and flowers to the 36 center blocks.

7. Using one strand of green embroidery floss, stem stitch around the top bud of the flowers. Using the green perle cotton thread, stem stitch along the inside curve of the flowers. Refer to "Embroidery Stitches" on page 100 as needed.

8. Assemble the quilt center using the quilt layout and the project photo as guides. You will sew six rows of six blocks each. Press seams in opposite directions from row to row.

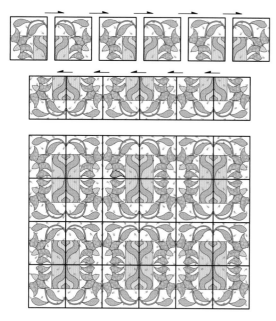

9. To add border 1, measure the width of the quilt across the center and cut the 3½" by 50" peach print A strips to this measurement. Now measure lengthwise through the center of the quilt and cut the 3½" x 56" peach print A strips to this measurement. Sew the side strips to the quilt center. Press seams toward the border. Sew a green polka-dot square to each end of the top and bottom border strips.

Sew the top and bottom strips to the quilt center. Press. Refer to "Borders with Corner Blocks" on page 106 as needed.

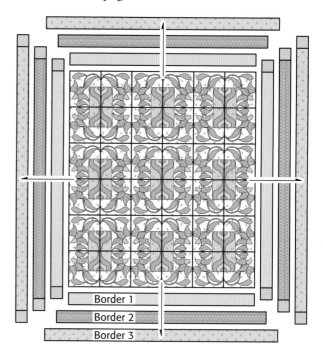

Border 1
Border 2
Border 3

10. Repeat step 9 to add the 3½"-wide strips of dark peach print (border 2) and the 3½"-wide strips of peach print B (border 3).

Finishing the Quilt

Refer to "Quilt Assembly and Finishing" beginning on page 105 for more details if needed.

1. Mark the quilting design on the quilt top if desired. See the quilting suggestion below.

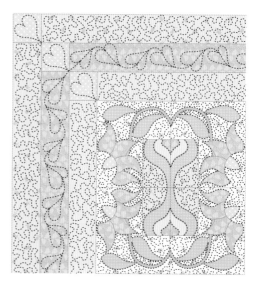

2. Layer the quilt top with batting and backing; baste.

3. Quilt by hand or by machine.

4. Use the green plaid strips to bind the edges of the quilt.

5. Add a label to the back of the quilt.

Appliqué Patterns and Placement Guide

Enlarge 125%.

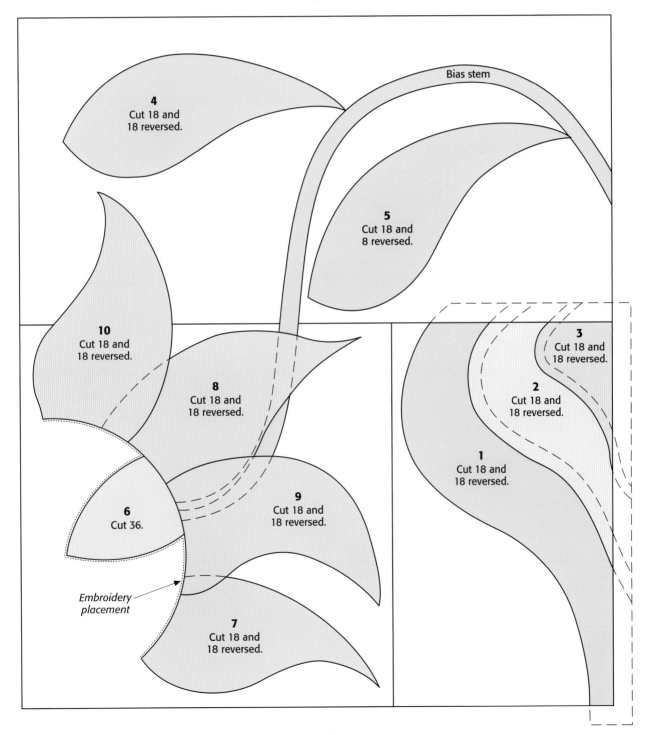

KISSED BY THE SUN

A wonderful combination of floral prints in blue and yellow
make this a sunny, happy quilt.

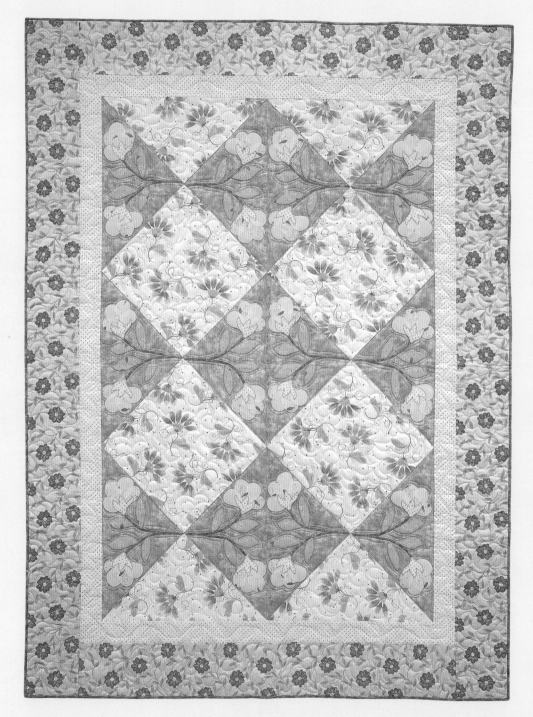

Finished quilt size: 57" x 77"

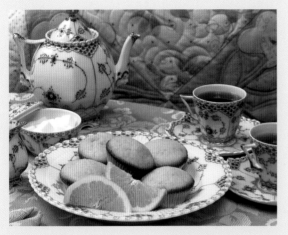

Tangerine Walnut Muffins

½ cup (1 stick) butter or margarine

¾ cup sugar

2 eggs

½ cup milk

1¼ cups all-purpose flour

1½ teaspoons baking powder

¼ teaspoon salt

½ cup chopped walnuts

1 tablespoon grated tangerine rind

Glaze:

3 tablespoons freshly squeezed tangerine juice

3 tablespoons sugar

Refer to baking directions detailed in "Basic Steps to Making Great Muffins" on page 11. While muffins are baking, make glaze by combining tangerine juice and sugar in a small pan. Heat over low heat until sugar is dissolved. Remove muffins from the oven and cool approximately 10 minutes. Prick muffin tops with a fork and spoon glaze over the muffins.

Yield: 8 muffins

Like the sun, they start with a glow

And grow and grow and grow

Materials

Yardage is based on 42"-wide fabric.

2½ yards of blue print A for outer border

2⅛ yards of yellow polka-dot print for inner border and flowers

1⅝ yards of yellow-and-blue print for center squares and triangles

1⅜ yards of blue print B for appliqué background

1 yard of green print A for bias stems and binding

⅞ yard of yellow print for flowers

⅜ yard of green print B for leaves

5 yards of fabric for backing

67" x 87" piece of batting

Cutting

All measurements include ¼" seam allowances. Cut strips across the width of the fabric unless otherwise indicated.

From green print A, cut:
- ½"-wide bias strips to total 192"
- 8 strips, 2" x 42"

From blue print B, cut:
- 3 squares, 21" x 21"; cut diagonally twice to make 12 quarter-square triangles

From the yellow-and-blue print, cut:
- 4 squares, 14½" x 14½"
- 1 square, 21" x 21"; cut diagonally twice to make 4 quarter-square triangles

From the yellow polka-dot print, cut on the *lengthwise* grain:
- 2 strips, 3" x approximately 42"
- 2 strips, 3" x approximately 67"

From blue print A, cut on the *lengthwise* grain:
- 2 strips, 6½" x approximately 47"
- 2 strips, 6½" x approximately 79"

Assembling the Quilt

1. Refer to "Making Bias Vines" on page 104 to make ¼"-wide bias stems from the green bias strips. Using the placement guide on page 84, position and pin the stems in place on the blue background triangles. Appliqué in position.

2. Choose your favorite appliqué method and make appliqué templates for the leaves and flowers by tracing the patterns on page 84. Refer to "Introduction to Appliqué" on page 98 for details as needed. Cut out the quantity indicated on the pattern for each shape.

3. Appliqué all flowers and leaves to the 12 blue triangles.

4. Assemble the appliquéd triangles and the squares and triangles of yellow-and-blue print in diagonal rows, referring to the quilt layout below. Sew the blocks together; press seams in opposite directions from row to row. Sew the rows together. Press the seams in one direction.

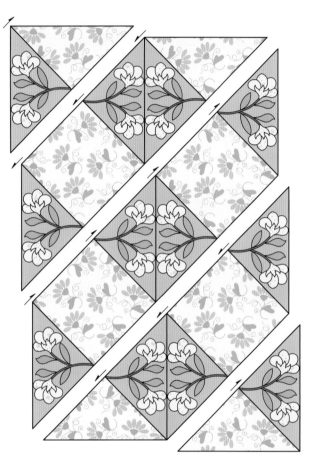

5. To add the inner border, measure the width of your quilt across the center. Cut the 3" x 42" yellow polka-dot strips to this measurement and sew them to the top and bottom of the quilt top. Press seams toward the border. To add the side border, measure lengthwise through the center of your quilt, including the borders just added. Cut the 3" x 67" yellow polka-dot strips to this

measurement and sew them to the sides of the quilt top. Press. Refer to "Borders with Butted Corners" on page 105 as needed.

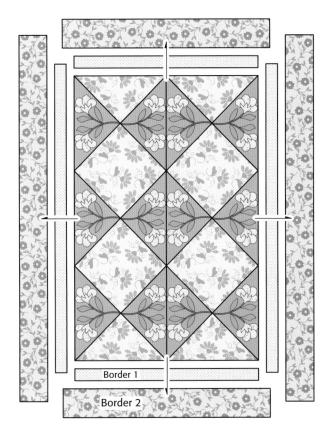

6. Repeat step 5 to add the blue print A strips for the outer border.

Finishing the Quilt

Refer to "Quilt Assembly and Finishing" beginning on page 105 for more details if needed.

1. Mark the quilting design on the quilt top if desired. See the quilting suggestion below.

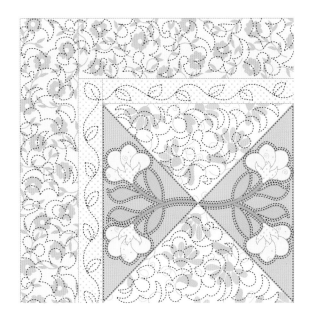

2. Layer the quilt top with batting and backing; baste.

3. Quilt by hand or by machine.

4. Use the remaining green strips to bind the edges of the quilt.

5. Add a label to the back of your quilt.

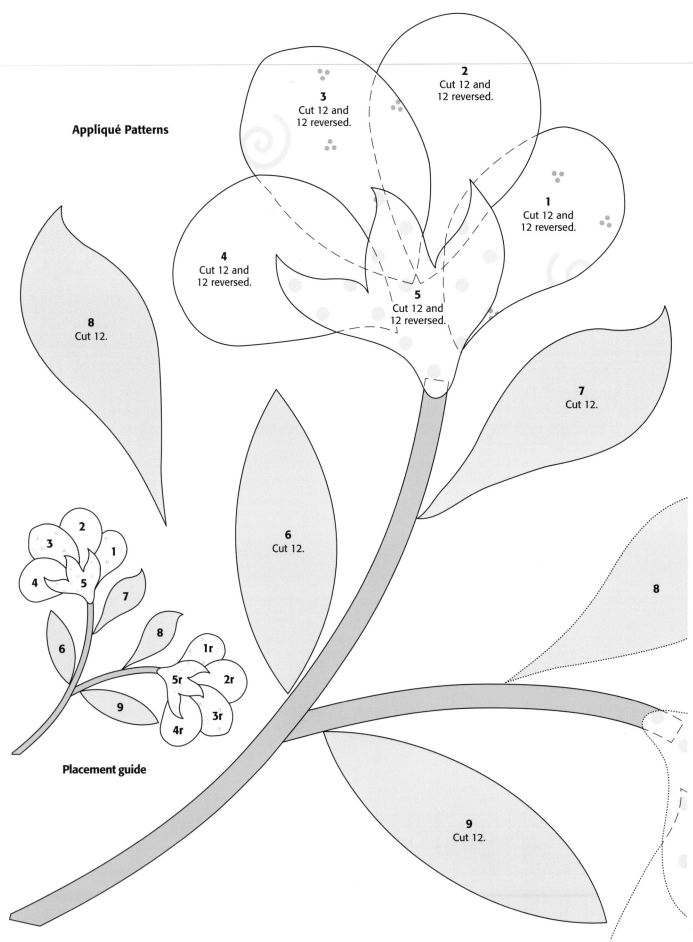

Appliqué Patterns

3
Cut 12 and
12 reversed.

2
Cut 12 and
12 reversed.

1
Cut 12 and
12 reversed.

4
Cut 12 and
12 reversed.

5
Cut 12 and
12 reversed.

8
Cut 12.

7
Cut 12.

6
Cut 12.

9
Cut 12.

8

Placement guide

LES FLEURS

*A flower patch of soft summer colors combined with
traditional appliqué and simple embellishments make a delightful
combination. What's not to like?!*

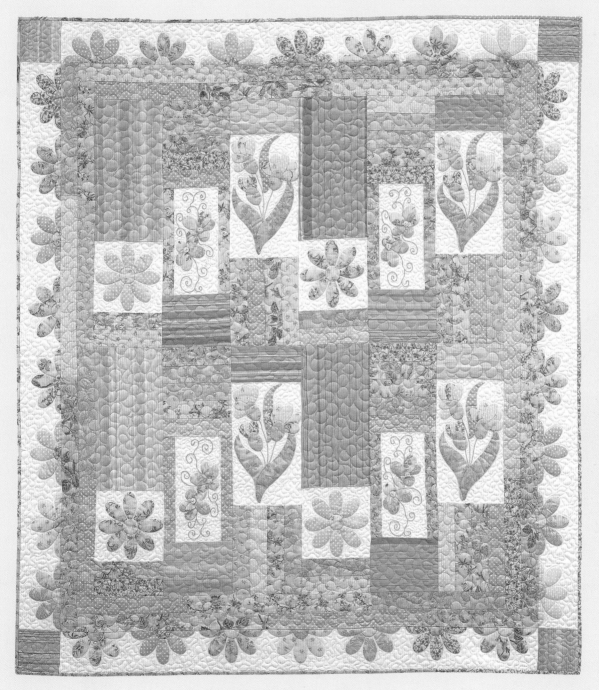

Finished quilt size: 50" x 56"

Carrot Walnut Muffins

⅓ cup vegetable oil

½ cup sugar

½ cup packed brown sugar

1 egg

½ cup milk

2 cups grated carrots

2 cups all-purpose flour

3 teaspoons baking powder

1 teaspoon cinnamon

½ teaspoon salt

1 cup chopped walnuts

Refer to baking directions detailed in "Basic Steps to Making Great Muffins" on page 11.

Yield: 12 muffins

One flower says friendship

Another means love

But no matter what they say

They all convey your thought of today

Materials

Yardage is based on 42"-wide fabric.

⅜ yard *each* of 4 yellow prints, 3 green prints, 1 lavender print, 1 blue print, 2 turquoise prints, and 3 pink prints for blocks, flowers, borders 1 and 2, and binding

1⅝ yards of off-white fabric for appliqué backgrounds and border 3

½ yard of blue multistriped fabric for blocks and corner square

½ yard of pink multistriped fabric for blocks and corner square

½ yard of yellow multistriped fabric for blocks and corner square

½ yard of green multistriped fabric for blocks and corner square

3¾ yards of fabric for backing

60" x 66" piece of batting

Green perle cotton size 8 embroidery thread

8 yellow buttons, ½" diameter, for flower centers

Cutting

All measurements include ¼" seam allowances. Cut strips across the width of the fabric unless otherwise indicated.

From the off-white fabric, cut on the *lengthwise* grain*:
- 2 strips, 4½" x 42½"
- 2 strips, 4½" x 48½"
- 4 squares, 6½" x 6½"
- 4 rectangles, 4½" x 9½"
- 4 rectangles, 6½" x 11"

From *each* of the 4 multistriped fabrics, cut:
- 1 rectangle, 6½" x 12½"
- 1 rectangle, 5" x 6½"
- 1 rectangle, 3½" x 6½"
- 1 square, 4½" x 4½"

From the yellow, green, lavender, blue, turquoise, and pink prints, cut a *total* of:
- 8 rectangles, 1½" x 9½"
- 28 rectangles, 2" x 6½"
- 16 rectangles, 2" x 8"
- 2"-wide strips of various lengths to total 575"

**For the borders, it will be easier to appliqué the flowers onto a wider strip and trim to the correct size after completing the appliqué. I suggest cutting the strips 5½" wide. If you're working with fabric that tends to ravel, you may want to cut all the pieces 1" larger. After completing your appliqué, trim them to the required size.*

Assembling the Quilt

1. Choose your favorite appliqué method and make appliqué templates for the leaves and flowers by tracing the patterns beginning on page 90. Refer to "Introduction to Appliqué" on page 98 for details as needed. Cut out the quantity indicated on the pattern for each shape.

2. Appliqué all leaves and flowers to the 6½" off-white squares, the 4½" x 9½" off-white rectangles, and the 6½" x 11" off-white rectangles.

3. Using the green perle cotton thread, stem stitch all vines and tendrils. Refer to "Embroidery Stitches" on page 100 as needed.

Note: If you have cut any of your appliqué blocks oversized, remember to trim them to the correct size before assembling the blocks.

4. The center of the quilt is made up of four pieced units. Using the multistriped rectangles, print rectangles, and appliqué blocks, assemble one pieced unit as shown. Press seams toward the darker fabric when possible. Each unit should measure 18½" x 21½". Make four of these units.

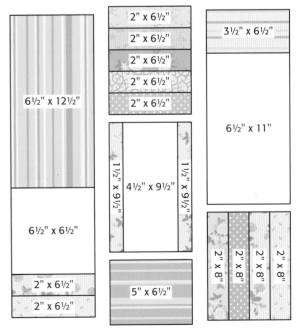

Make 4.

5. Sew the units from step 4 together to make the quilt center. Press seams in opposite directions. The quilt center should measure 36½" x 42½".

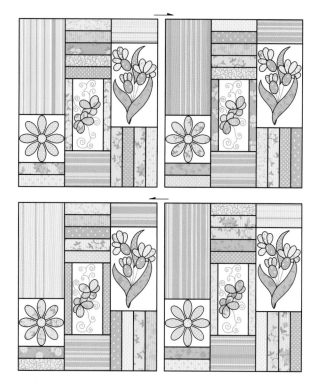

6. Make border 1 by piecing 2"-wide strips of various lengths cut from the print fabrics. Piece two strips having a total length of 36½" and sew them to the top and bottom of your quilt. Press seams toward the border. Piece two strips having a total length of 45½" and sew them to the sides of your quilt. Press.

36½"

Top/bottom border.
Make 2.

45½"

Side border.
Make 2.

7. Repeat step 6 to make strips for border 2, piecing 2"-wide strips of various lengths to measure 39½" for the top and bottom of the quilt. The side border strips should measure 48½". Add the top and bottom border strips to the quilt and then add the side borders.

8. Allowing for a ¼" seam allowance on each end, divide the remaining length of the 4½" x 42½" off-white strips into seven segments, 6" wide. Divide the 4½" x 48½" strips into eight segments each. If you cut your border strips wider, mark the sewing line. Use that as a placement guide when you position the flower petals and flower centers. Appliqué all flower petals and flower centers.

6¼" 6" 6" 6" 6" 6" 6¼"

6¼" 6" 6" 6" 6" 6" 6" 6¼"

EASIER APPLIQUÉ

Appliqué the complete flower petals and flower centers to the excess fabric. When you have completed the appliqué, trim the border strips to the correct measurements and sew them to the quilt center.

9. Sew the top and bottom border strips to the quilt. Press seams toward border 2.

10. Sew a multistriped corner square to each end of the side border strips. Press seams toward the corner squares. Sew the side border strips to the quilt. Press.

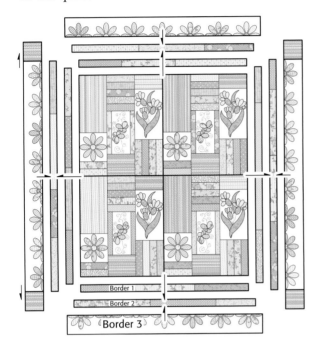

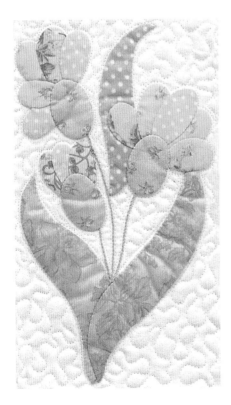

Finishing the Quilt

Refer to "Quilt Assembly and Finishing" beginning on page 105 for more details if needed.

1. Mark the quilting design on the quilt top if desired. See the quilting suggestion below.

2. Layer the quilt top with batting and backing; baste.

3. Quilt by hand or by machine.

4. Piece together the remaining 2"-wide print strips to measure 225" for the binding. Bind the edges of the quilt.

5. Sew the yellow buttons to the flower centers. Refer to "Buttons as Flower Centers" on page 17.

6. Add a label to the back of your quilt.

**Appliqué Patterns and
Placement Guide**

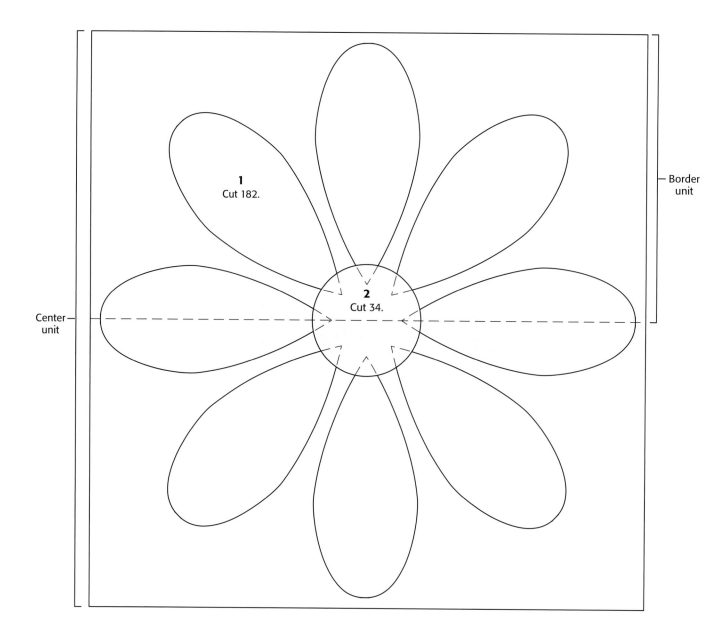

1
Cut 182.

2
Cut 34.

Border
unit

Center
unit

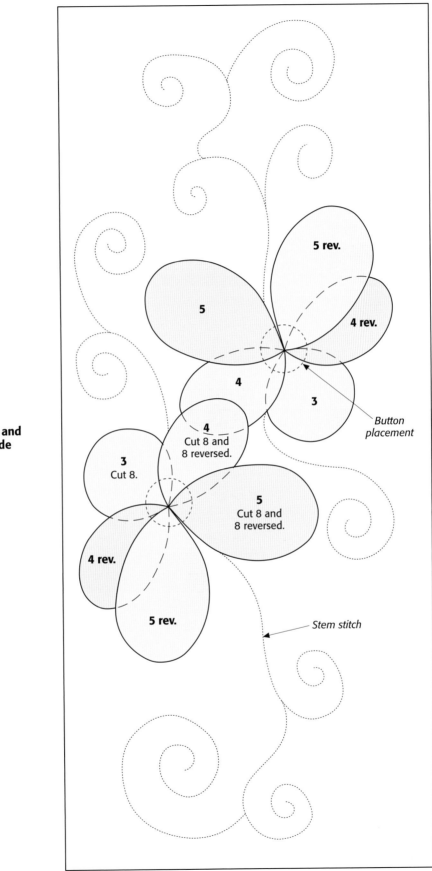

Appliqué Patterns and Placement Guide

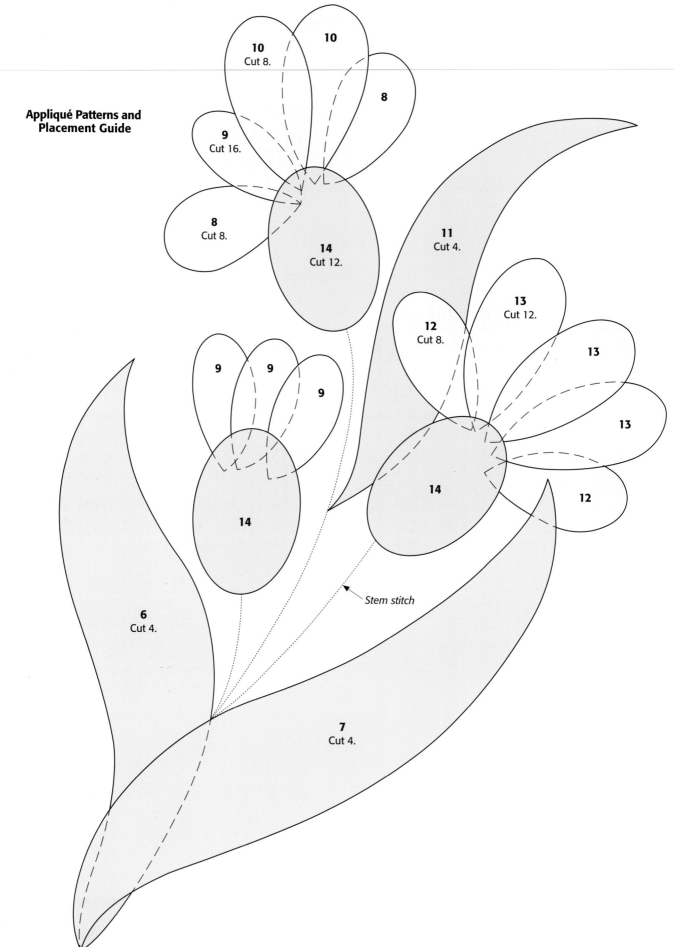

Appliqué Patterns and Placement Guide

10
Cut 8.

10

8

9
Cut 16.

8
Cut 8.

14
Cut 12.

11
Cut 4.

13
Cut 12.

12
Cut 8.

13

9

9

9

13

13

14

12

14

6
Cut 4.

Stem stitch

7
Cut 4.

QUILTMAKING TOOLS AND TECHNIQUES

In this section you will find recommendations and guidelines for essential tools and techniques to enhance your quiltmaking experience. If you're a beginning quilter, it can be overwhelming to sort through the array of products available. To start out, purchase only the essential items, and buy the very best quality. These tools will be an investment and will be part of your sewing studio for many years to come.

As you expand your skills and become a more experienced quilter, it's always fun to invest in new products and try new gadgets, but you will never outgrow the basic tools. I spend much of my year traveling, and of course I always take my quilting projects with me. When I narrow down the items in my sewing studio to what I will pack in my suitcase, I select only the things I just can't live without. I always find that those few essential tools I first purchased are still the key components of my portable studio.

Fabric

Purchase high-quality, 100%-cotton fabric. If you can, always purchase a little extra. Mistakes happen, and I say, "Better a little extra, than not enough." Choosing a wide variety of fabrics will make your quilt interesting and exciting. Always prewash, dry, and press your fabrics before you use them.

Thread

For appliqué and piecing, purchase good-quality cotton or cotton-covered polyester thread. For piecing, use 50-weight thread. For appliqué, you might like to use a lighter 60-weight cotton thread or a 100%-silk thread. These lighter-weight threads are easier to thread through the small eye of the thin needles (Sharps) used for appliqué.

Quilting thread comes in an array of colors and textures, in cotton, rayon, and polyester. You will find it fun to experiment to find just the right thread for your project.

Needles

A good-quality needle will glide through your fabric and make sewing your project a pleasure. Needle sizes are designated by number: the larger the number, the smaller the needle. Choose the correct needle to use for different steps of the quilting process.

- **Betweens** are shorter, thicker needles used for hand quilting.
- **Sharps** are slightly longer, thinner needles with a small eye, used for hand appliqué.
- **Crewels** are long needles with a large eye that are helpful when using heavier-weight threads to embellish your quilt.

Between —————————
Sharp ——————————
Crewel ———————————

For machine piecing or machine quilting, use machine needles in size 70/10, 80/12, or 90/14.

Thimbles

Thimbles come in a variety of shapes, sizes, and materials. My personal favorite is an antique silver thimble that I received as a gift. It's a treasure! If you're planning to hand piece, hand appliqué, or hand quilt, you will want to wear a thimble to protect your fingertip. Try several to see which you find most comfortable.

Pins

I suggest having several different types of pins on hand. They will make your sewing life easier.

- **Silk pins** are fine, sharp pins with plastic or glass heads that are excellent for pinning patchwork pieces together.

- **Sequin pins** are ¾" pins that are excellent for pinning appliqué pieces to the background fabric. Their short length prevents your sewing thread from catching on them during the stitching process.

- **Quilter's pins** are extra-long pins with plastic heads that are used to pin the layers of the quilt together when you're planning to baste and quilt by hand.

- **Safety pins** are used for pin basting your quilt when you will be machine quilting. Be sure to purchase rustproof pins.

Scissors

Use craft scissors when cutting plastic or paper templates for piecing or appliqué. Save one high-quality pair of scissors exclusively for cutting fabric. Small, very sharp 4" scissors are excellent for clipping threads or trimming appliqué pieces.

DON'T FORGET

When you're outfitting your sewing room, remember to purchase a seam ripper. This small but necessary tool is a sharp, pointed gadget that makes it quick and easy to remove machine-stitching errors—a process sometimes referred to as "unsewing."

Marking Tools

There are a variety of marking tools available for use on fabric when you need to draw around appliqué templates or piecing templates, or draw quilting lines. I prefer to use a No. 2 pencil or a fine-lead 0.5-mm mechanical pencil to lightly mark my fabric. No matter what tool you choose, be sure to test it with scrap fabric to make sure you can easily remove the marks.

Light Box

A light box usually consists of a box made of wood or other material with a plastic top and an electric light inside. There are many types and sizes to choose from at arts-and-crafts supply stores. Tracing patterns to make templates for appliqué and positioning your appliqué pieces on your background fabric is very easy when you use a light box. If you don't have a light box, you can use a glass-top table with a light underneath, or you can tape your pattern to a window for tracing.

Rotary-Cutting and Measuring Tools

Rotary cutting is a fast, accurate way to cut your patchwork pieces. You will need to purchase a self-healing cutting mat, a rotary cutter, and some clear acrylic rulers with both vertical and horizontal measuring lines. Some useful sizes include 4" x 4", 6" x 6", 6" x 12", 6" x 24", and 15" x 15". An extra-long, 120" tape measure is ideal for measuring your quilt top when adding borders.

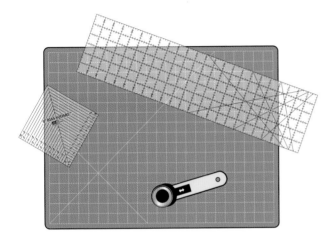

Rotary Cutting

Rotary cutting is usually associated with machine piecing, since the sewing line is not marked and the ¼" seam allowance is included in the cutting dimensions. Even if you're hand piecing, you can rotary cut your pieces. Simply mark the ¼" seam allowance after cutting. It will save you from making templates and cutting out your patch-work pieces with scissors. See "Hand Piecing" on page 96 for further details.

1. Fold the fabric and match the selvages. Place the folded edge closest to you on the cutting mat. Align a square ruler along the folded edge of the fabric. Place a long ruler to the left of the square ruler, covering the uneven raw edges of the fabric. Remove the square ruler and hold the long ruler firmly with your left hand. Cut along the right edge of the long ruler with a rotary cutter. Now you have a straight edge to cut strips and other shapes.

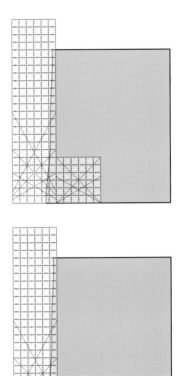

2. To cut strips, align the newly cut edge of the fabric with the appropriate line on the ruler for the required width. Cut the strip.

3. To cut squares or rectangles, first cut a strip the required width. Trim the ends and then align the left edge with the correct ruler lines. Cut the squares or rectangles as needed.

4. To cut a half-square triangle, determine the finished length of the short side of the triangle and add ⅞". Cut a square this measurement and cut across it diagonally once from corner to corner. Each square yields two half-square triangles, with the straight grain of the fabric on the short sides.

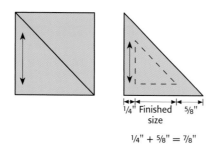

¼" Finished ⅝"
size

¼" + ⅝" = ⅞"

5. To cut a quarter-square triangle, determine the finished length of the long side of the triangle and add 1¼". Cut a square this measurement and cut it diagonally twice. Each square yields four quarter-square triangles, with the straight grain of the fabric on the long side of the triangle.

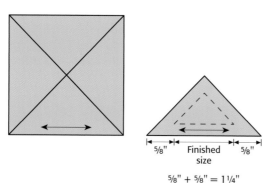

⅝" Finished ⅝"
size

⅝" + ⅝" = 1¼"

Hand Piecing

I love hand piecing because you can do it anytime, anywhere—at home or while you're traveling. Early quilts were all hand pieced; I consider it the time-honored method of constructing a quilt.

1. To cut your patchwork pieces with traditional templates, make a template from either light-weight plastic or cardboard in the exact size of the finished patchwork piece. I recommend plastic because it will not wear down with continued use. Place the template on the wrong side of your chosen fabric, being aware of the grain lines of the fabric. Trace around the template with a No. 2 pencil. Leave at least ½" between the tracings. The drawn lines are your sewing lines. Cut out each piece with scissors, leaving a ¼" seam allowance around the tracing.

Trace around the template.

To cut with a rotary cutter, follow the instructions in "Rotary Cutting" on page 95. Rotary-cut pieces will include the ¼" seam allowance, but no sewing line.

2. Place two fabric pieces right sides together and pin, matching pencil lines exactly at the corners and along the seam line. Use a regular sewing thread in a matching color, knotted at the end. Stitch the fabric pieces together using a small running stitch. Backstitch and knot the thread at the beginning and end of each seam to secure your stitching. Seam allowances should remain

free. Trim seams so they are ⅛" to ¼" wide. Press the seams toward the darker fabric when possible. When sewing patchwork units together, avoid sewing across the seam allowance. On long seams, backstitch at regular intervals to secure your seam.

Machine Piecing

The most important thing to remember in machine piecing is to maintain an accurate ¼" seam allowance so that all your patchwork pieces fit together perfectly. Set your machine stitch length at approximately 10 to 12 stitches per inch. Line up the cut edges of your fabric pieces precisely and stitch. Backstitching is not necessary, since the seams will cross each other.

Chain piecing your patches will save you both time and thread, and is an especially efficient method if you're sewing several identical units. To chain piece, sew your first pair of patches together. At the end of the seam line, stop sewing but do not cut the thread. Feed the

next pair of patches under the pressure foot and continue sewing in the same manner until all the patches are sewn. Remove the chain patches from the machine and clip the threads between the pairs of sewn patches.

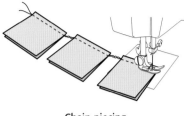

Chain piecing

If it is necessary to sew two patches or units together that are slightly different in size, pin the pieces together as they should match, distributing the fullness evenly between the pins and adding more pins if necessary. Sew the seam line with the larger piece of fabric underneath. The feed dogs will ease the bottom fabric to fit with the top fabric.

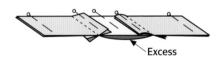

Excess

Press your seams as you go. Plan your pressing so that the seams are pressed in opposite directions. This eliminates bulk and ensures that the seams nestle together as you sew. Press seams toward the darker fabric whenever possible.

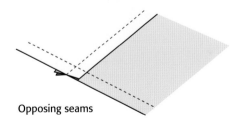

Opposing seams

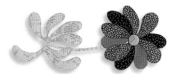

INTRODUCTION TO APPLIQUÉ

Have you ever been really excited about something you've tried? So excited you're tingle happy? You love it, you want to keep doing it, and you want that feeling to stay with you. You're so excited you want to tell the whole world about it. You want to stand on the tallest building and yell, "People, you have to try this! You will love it!" That's how I feel about appliqué.

Appliqué is a dimension of quilting that expands your skills and knowledge; it enables you to express yourself in ways that straight lines alone cannot do. With appliqué, you can tell a story and incorporate the world into your quilts. Appliqué adds depth, dimension, and movement. When you have learned the basic skills to do appliqué, every other area of quilting seems like a natural progression. Appliqué helps you see outside the grid and sets you free to choose your own path and develop your own unique style.

I use three different methods of appliqué: fusible, freezer paper, and needle-turn. Each method uses different techniques. Once you become familiar with each appliqué method you may find that a particular technique or method works best for you or your particular project. Or, you may find it fun and exciting to use a combination of methods and techniques. Experiment and play with the methods. Have fun! Get tingle happy! That's when we become our most creative.

Fusible Appliqué

Fusible appliqué is fast and easy because there are no seam allowances to turn under. Instead, a bonding material, called fusible web, is used to adhere the appliqué piece to the background fabric. Is fusible appliqué cheating? No, absolutely not! It's just a helping hand to hold your appliqué piece in position until you can sew it down. In many instances, fusible appliqué is my preferred method of choice. In fusible appliqué, all of your stitches are showcased on the top of the quilt, rather than underneath as they are in traditional appliqué. I enjoy hand stitching, and fusible appliqué gives me the opportunity to use a variety of embroidery stitches in combination with embellishments, adding depth and interest to my quilt. If you like to use your machine, rather than hand stitch, fusible appliqué provides an opportunity to use all those wonderful decorative stitches on your sewing machine to cover and stitch the edges of your motifs.

Fusible web has smooth paper on one side, with an adhesive on the reverse side. There are many brands on the market, including HeatnBond, Wonder-Under, and Steam-A-Seam. If you're going to hand stitch your project, choose the most lightweight fusible web possible. This is especially important if you're hand stitching through multiple layers of fused fabrics. The adhesive does stiffen the fabric, so even if you're machine stitching the edges of your motifs, choose a lightweight fusible product so that your quilt will be soft and pliable. Be sure to follow the manufacturer's specific directions for the fusible product you choose.

KEEP IT SOFT

If your design results in multiple layers of fused fabrics, you can reduce stiffness by cutting away all but ¼" of the fusible web inside the traced lines. This trimming allows the shape to adhere to the background fabric but eliminates the stiffness of the adhesive within the shape.

With fusible appliqué, you will draw or trace your templates in reverse. Use a light box, if available, or an alternative arrangement for tracing. Refer to "Light Box" on page 94.

1. Place your pattern right side down on your light box. Place the fusible web on top of your pattern, with the smooth, paper side up.

2. Use a pencil to trace around the appliqué pattern.

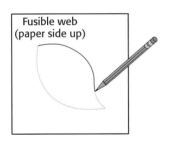

Fusible web
(paper side up)

3. Cut the shape from the fusible web, leaving approximately ¼" outside the traced lines.

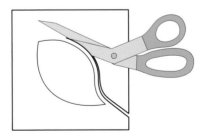

4. Place the fusible-web shape on the wrong side of your chosen fabric. Following the manufacturer's instructions, press it with an iron. Let it cool.

5. Before cutting out the fabric shape, pull up slightly on one corner of your fusible web to loosen it. This makes it easier to remove the paper and prevents your fabric from fraying. Now cut out the fabric shape on the drawn lines and remove the backing paper.

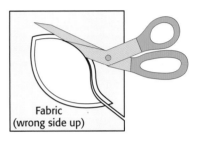

Fabric
(wrong side up)

6. Using your pattern as a guide, position the appliqué shape, adhesive side down, on the right side of the background fabric and press.

7. When all the pieces are fused, finish the edges with a decorative stitch, either by hand or by machine.

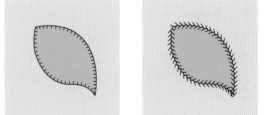

FUSIBLE Q & A

"Does fusible appliqué hold up to long-term wear and tear?" This is a question I am frequently asked. Yes, it does! I recently hand stitched a fusible-appliqué block and put it through the heavy-duty cycle of my washing machine five times. Dried and pressed, it looked fabulous!

Embroidery Stitches

When hand stitching the edges of fusible-appliqué designs, my two favorite stitches are the blanket stitch and the feather stitch. I use one strand of six-strand embroidery floss in a complementary color. For adding veins to leaves or stitching vines and tendrils, I use the stem stitch. The loop stitch is nice to add dimension to flowers and is an option you may wish to use to embellish your quilting projects.

Blanket Stitch. Bring the needle up at the edge of the piece and work from left to right.

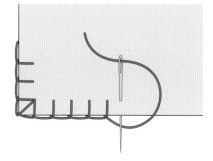

Feather Stitch. Bring the needle up at A and down at B, creating a U shape. Bring the needle up at C to anchor the U, and then insert it down at D, creating a second U. Repeat. Keep your stitches small and make sure that the edges of the design are covered by the stitches.

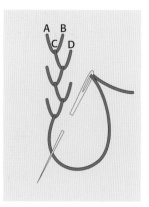

Stem Stitch. Bring the needle up at A and down at B. Repeat, bringing the needle up at C and down at D. Continue, keeping the thread on the same side of the stitching line.

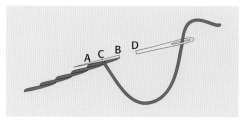

Loop Stitch. Bring the needle up at A and down at B, leaving a loop of thread the desired length. Bring the needle up at C and down at D, coming up again at C and down at D to make a small anchoring stitch that will hold the loop in position. Make the next loop close to the first loop. Repeat to continue making loops.

Freezer-Paper Appliqué

Freezer-paper appliqué has the look and feel of traditional needle-turn appliqué but is, in fact, a much easier process. The freezer paper acts as a sewing guide, eliminating the need for drawn lines that have to be hidden during the appliqué process.

Freezer paper is sold in most supermarkets in the same aisle as the plastic bags and storage containers. It is a white, heavy paper, dull on one side and shiny on the reverse. Be sure to purchase paper that is plastic coated.

In freezer-paper appliqué, you cut templates from the freezer paper and use them as a guide to turn under a seam allowance, either on top of or underneath the appliqué piece. I prefer to use the freezer paper underneath, but I encourage you to try both methods to see which works best for you. You can reuse templates several times, if you wish, before discarding them.

Freezer Paper Underneath

As in fusible appliqué, draw your templates reversed.

1. Place the pattern right side down on a light box. Place the freezer paper shiny side down on top of the pattern and trace around the pattern with a pencil.

2. Cut out the freezer-paper template on the drawn lines.

3. Place the template on the wrong side of your chosen fabric. Press.

4. Trim the fabric around the paper template, leaving ⅛" to ¼" for seam allowance.

Fabric
(wrong side up)

5. Using your pattern as a guide, place your appliqué piece in position, paper side down. Pin in position with ¾" sequin pins.

6. Thread a Sharp needle with a colored thread that matches the color of the piece you're appliquéing. Knot the end.

7. Turn under a small section of seam allowance; use the edge of the freezer paper as a folding guide. Start your first stitch by bringing the needle up through the background fabric and through the edge of the folded appliqué fabric. Insert the needle back down through the background fabric and up again about ⅛" away.

8. Continue to take small, even stitches in a counterclockwise direction, turning under the seam allowance as you go and catching just the edge of the fold with each stitch.

Appliqué stitch

9. When you're about ½" from where you began stitching, fold under the remaining seam allowance and finger-press. Using tweezers, loosen the enclosed freezer paper and remove it through the unstitched opening.

10. Refold the seam allowance and continue stitching a couple stitches past where you began. Make a knot on the wrong side of the background fabric.

Freezer Paper on Top

1. Place your pattern right side up on the light box. Place the freezer paper shiny side down on top of the pattern and trace around the appliqué design with a pencil. Cut out the freezer-paper template on the drawn lines.

2. Place the template on the right side of your chosen fabric. Press.

3. Cut around the paper template, leaving approximately ⅛" to ¼" for seam allowance.

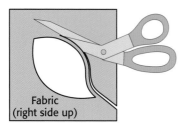

Fabric
(right side up)

4. Using your pattern as a guide, place your appliqué piece in position, paper side up. Pin in position with ¾" sequin pins.

5. Use the edge of the freezer paper as your guide for turning under the seam allowance. Stitch as described in steps 6–8 of "Freezer Paper Underneath" on page 101.

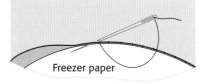

Freezer paper

6. Continue stitching a couple stitches past where you began. Knot the thread on the wrong side of the background fabric. Remove the freezer paper.

Needle-Turn Appliqué

Traditional needle-turn appliqué is the tried-and-true method our grandmothers used. It works especially well on very small or intricate appliqué pieces. The only thing you have to remember is to be sure to turn under enough seam allowance to cover your drawn lines.

1. Place your pattern right side up on a light box. Make a template of the appliqué design and cut out the template on the drawn lines. The template material may be plastic, cardboard, or even freezer paper. If you're reusing the template several times, make it from template plastic so the piece retains its correct size and shape.

2. Place the template on the right side of the chosen appliqué fabric and trace around it with a No. 2 pencil.

3. Cut out the fabric shape, leaving ⅛" to ¼" for seam allowance.

4. Place your appliqué piece in position, right side up, using your pattern as a guide. Pin in position with ¾" sequin pins.

5. Thread your Sharp needle with a thread that most closely matches the color of the piece you're appliquéing. Knot the end.

6. Turn under a small section of seam allowance using your needle and finger-press. Start your first stitch by bringing the needle up through the background fabric and through the edge of the folded fabric. Insert the needle back down through the background fabric and up again about ⅛" away.

7. Continue to take small, even stitches in a counterclockwise direction, turning under the seam allowance with the tip of the needle as you go and catching just the edge of the fold with each stitch. Be sure to turn under enough seam allowance to cover your drawn lines.

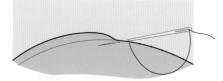

8. Continue stitching a couple stitches past where you began. Knot the thread on the wrong side of the background fabric.

HELPFUL HINTS FOR HAND APPLIQUÉ

Whether you choose to use the freezer-paper appliqué method or the needle-turn appliqué method, these tips will help you achieve a quality finished project.

- Sew the appliqué motifs to the background fabric in the order indicated in the project instructions. Remember that you're building a picture and you must work from the background out to the foreground.

- Do not sew edges that will be covered by other motifs.

- When you turn under the seam allowance, use the tip of your needle. You may also use what I call the "toothpick method." Use a Chinese toothpick (pointed on only one end) or a regular round toothpick. Moisten it slightly and use the point to roll, turn, and smooth the seam allowance ahead of you as you sew.

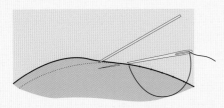

- If you're working with fabric that frays easily, leave a larger-than-normal seam allowance and trim to the required ⅛" to ¼" as you stitch the appliqué piece in position.

- When appliquéing both inner and outer curved edges, clip the seam allowance at regular intervals to allow it to expand and curve smoothly.

- When appliquéing an inner point, clip at the point. Stitch to the clip, take one or two stitches right at the clip, and then turn and continue to sew.

- When appliquéing points, take two stitches at the point. Flip the point back and trim away excess fabric from underneath before turning and continuing to sew down the next side. This should give you a sharp, flat point.

Flip back and trim excess fabric.

Making Bias Vines

Bias strips are used for making flower stems and vines. Using a bias-tape maker is the fastest and easiest method I have found to make bias stems. This tool comes in a variety of sizes from ¼" to 2". To make a ⅛"- to ¼"-wide bias stem, cut a ½" bias strip that is at a 45° angle to the selvage of your fabric. Use your longest rotary ruler and line up the 45° angle with the selvage edge.

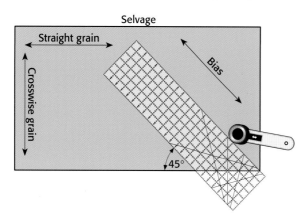

You may need to piece strips together to obtain the length needed. To do this, place the strips right sides together, offsetting them by ¼". Stitch together, leaving a ¼" seam allowance. Press the seams open to minimize bulk.

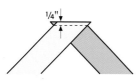

1. Place one end of the bias strip into a ¼" bias-tape maker. Pull just the tip of the strip through the bias-tape maker and pin it to your ironing board.

2. Continue to pull the bias-tape maker slowly along the strip, following closely behind the bias-tape maker with your iron to crease the edges of the fabric as it emerges from the bias-tape maker.

3. Pin in position with ¾" sequin pins; appliqué with matching thread.

EASY PRESSING

If you're working with fabric that will not hold a crease well, lightly spray the bias tape with spray starch and press.

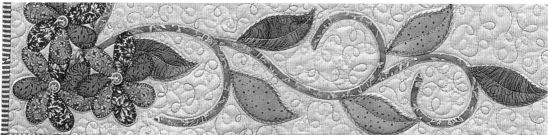

QUILT ASSEMBLY AND FINISHING

This section contains all the information you need to move from finished blocks to finished quilt.

Setting the Blocks Together

Traditionally, quilt blocks are set together either in straight rows or on a diagonal. For either setting, follow these basic steps:

1. Ensure that each block is the same size.

2. Sew the blocks of each row together.

3. Press the seams of each row in opposite directions.

4. Sew the rows together.

5. Press as you go.

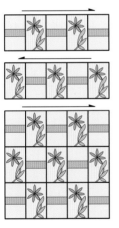

Straight setting

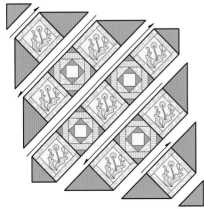

Diagonal setting

Adding the Borders

After you have sewn all the blocks together, it's time to add the borders. Seam allowances can vary and some stretching may have occurred as you handled your blocks, so always measure through the center of your quilt to determine the exact length of your borders. This will prevent your borders from rippling. In the cutting instructions, I often have you cut the border strips longer than necessary. This allows you to trim the border strips to the exact measurement of your quilt after the blocks are sewn together.

Note that in my quilts, I do not piece the borders. I like to cut the borders lengthwise to avoid piecing strips cut across the width of the fabric. This requires extra fabric at times, but I believe it is worth it. The yardage amounts listed for each project allow for lengthwise cutting of borders.

Borders with Butted Corners

1. To add the top and bottom borders, measure the width of your quilt across the center. Trim the top and bottom border strips to this measurement and sew them to the top and bottom of your quilt. Press the seams toward the borders.

2. To add the side borders, measure lengthwise through the center of your quilt, including the top and bottom borders. Trim the side border strips to this measurement and sew them to the sides of your quilt. Press the seams toward the borders.

3. Repeat this same process for each border added.

Borders with Corner Blocks

1. Measure your quilt through the middle from side to side and from top to bottom. Cut the four border strips to these measurements. Sew the side border strips to the quilt top. Press the seams toward the borders.

2. Cut corner squares the required size. Sew a corner square to each end of the top and bottom border strips. Press the seams toward the border strips. Sew the top and bottom border units to the quilt top, matching seams. Press seams toward the border strips.

Borders with Mitered Corners

1. Estimate the finished dimensions of your quilt, including the borders. Then add an additional 4" to 5" to these measurements. As an example, if the finished dimensions of your quilt will be 35" by 40", you will cut two border strips 40" and two border strips 45".

2. Find the center point of the top and bottom edges of the quilt as well as the center point on each side and mark with a pin. Fold each border strip and mark the center with a pin.

3. Measure both the length and width of the quilt top through the center.

4. Place a pin at each end of the side border strips to mark the correct measurement. Repeat for each top and bottom border strip.

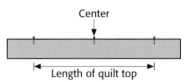

5. Pin a border strip to the quilt top, matching the center points. Stitch the border in place, beginning and ending the stitching ¼" from the raw edges of the quilt top. Repeat for the remaining three border strips.

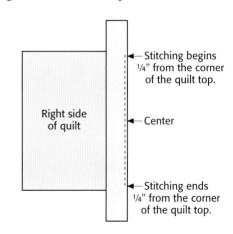

6. Lay the first corner to be mitered on your ironing board. Fold under one border strip at a 45° angle to the other strip. Press and pin.

7. Fold the quilt right sides together, lining up the edges of the two border strips. Using a pencil, draw a line on the crease to help you see the sewing line more clearly. Stitch on the crease line, sewing from the corner to the outside edges of the border strips.

Pressed crease

Wrong side of quilt

8. Press the seam open and then check the right side of the quilt to make sure the mitered corner is neat. Trim away excess fabric, leaving a ¼" seam allowance.

9. Repeat steps 6 through 8 to miter the remaining three corners.

Please note that if your quilt has multiple borders, you may sew the individual border strips together first and treat the resulting unit as a single border. Line up the border strips according to their centers. The edges will be staggered as shown. The inner-border strips do not need to be as long as the outer-border strips. When mitering the corners, pin carefully to match the seams of each border.

Match centers.

Quilting

Now your quilt top is finished. You need to decide if you will quilt by hand or by machine and what designs you will use.

If you're planning a complex quilting design, you will probably want to mark the design on the quilt top. It is always preferable to do the marking before layering and basting the quilt. This will ensure accurate lines that are easy to follow. You may find it easier to tape your quilt top to the floor or a large table with masking tape to keep the quilt from slipping and to make it easier to mark the quilting lines.

To verify that the marking lines will be either covered by the quilting stitch or easy to remove when the quilting process is complete, always test any marking tool you choose to use.

To draw straight lines on your quilt, use an acrylic ruler with multiple parallel lines to keep your drawn lines straight. For more complex designs, you might choose to purchase quilting templates or stencils that come in a wide array of sizes and designs.

Backing

I love to use print fabrics for the backing of my quilts. Once the quilt is quilted, it's like getting two quilts in one. Print fabrics also camouflage less-than-perfect quilting stitches.

Cut the backing fabric 5" larger than the quilt top on all sides (10" larger overall). This makes hand quilting the borders of your quilt easier, because you will have enough fabric to fit into a quilting frame or hoop.

It might be necessary to piece the backing of your quilt using two lengths of fabric or, if the quilt is very large, three. You may position the seams either horizontally or vertically. Press the seams open to eliminate bulk.

Two lengths of fabric seamed in the center

One fabric width

Partial fabric width

Batting

How you plan to quilt and use your quilt will determine the type of batting you choose. There are many choices: polyester, cotton, a cotton-and-polyester blend, or wool. If you're planning to hand quilt, generally the thinner the batting, the easier it is to quilt. If you're hand quilting and choose a cotton batting, try to avoid battings that contain a bonding material called scrim. The scrim does help to stabilize the batt but it makes it difficult to hand needle.

Thin to medium-weight battings, in the materials mentioned above, may be used for machine quilting. Thicker, heavier battings are usually used only if you plan to tie your quilt.

It is always interesting to talk to a group of quilters and find out which batting they prefer to use. The answers always differ, and loyalties are usually strong for a particular type or brand. I recommend you try several different types and brands to see which works best for you personally.

Layering the Quilt

You are now ready to baste the quilt top, batting, and backing together so they don't shift during the quilting process. Be sure to press the backing and the top before basting so they are wrinkle free and easy to handle.

1. Place the backing, right side down, on a large table or the floor. Use 1½"-wide masking tape to fasten the corners and sides of the backing to the work surface, smoothing away any ripples as you work.

2. Lay the batting on top of the backing. Smooth out any ripples. Trim the batting so it's the same size as the backing fabric.

3. Lay the quilt top right side up on top of the batting. Use masking tape to fasten the corners and sides of the quilt top in position, smoothing out any ripples as you work.

4. **For machine quilting,** use rustproof safety pins for basting the layers together. Basting stitches can easily get caught on the sewing machine as you're quilting. Place pins about 4" apart. Remove the masking tape.

 For hand quilting, pin all layers together with long quilter's pins. Hand baste all three layers together using a light-colored thread. Dark threads may stain light fabrics if left in for a long period of time. Stitch basting rows both horizontally and vertically, approximately 4" to 6" apart. Also place a row of basting around all edges of the quilt. Remove the pins and masking tape.

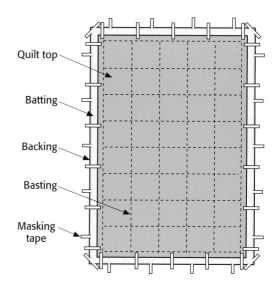

Quilt top

Batting

Backing

Basting

Masking tape

Hand Quilting

For hand quilting, you will use quilting thread and a short Between needle. Beginning quilters might do best with a larger needle such as size 8 until they become comfortable with the quilting process. Quilting Betweens range in sizes from 8 to 12. Remember: the larger the number, the smaller the needle. In hand quilting, the object is to achieve small, even stitches. With practice, your stitch size and spacing will become consistent.

Most hand quilters prefer to use a hoop to support their quilt while they work. This can be a hoop held in your lap or a hoop supported on a stand.

1. Place the quilt in the hoop. Make sure the quilt is not pulled too tightly within the frame, because this distorts the quilt's shape and makes it difficult to achieve the rocking motion that produces small, even stitches.

2. Thread the needle with a length of quilting thread approximately 18" to 20". Knot one end of the thread.

3. Approximately 1" from where you want to start quilting, insert the needle between the layers of the quilt and come up at the point where you wish to start. Tug the thread and pop the knot through the fabric so that it is buried between the layers of the quilt.

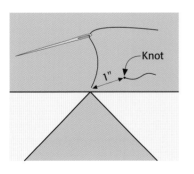

4. Wear a thimble with a raised edge on your middle finger to help control and push the needle during the rocking, down-up motion of the needle. Place your other hand under the quilt to ensure that the needle is traveling through all three layers of the quilt with each stitch. Use your thimble to push the needle down through the layers until you feel it with the finger of your underneath hand. Then rock the needle back up through the layers to the top. Repeat to load several stitches on the needle before pulling the thread through.

5. At the end of the quilting line, take a small backstitch. Make a knot close to the surface of the quilt top. Tug and pop the knot so that it is buried between the quilt layers. Clip the thread close to the surface of the quilt top, and the tail will disappear between the layers of the quilt.

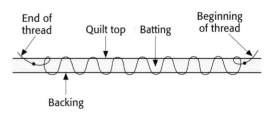

6. When the quilting is complete, remove all basting threads from the quilt.

Machine Quilting

If you're going to machine quilt, you will find it helpful to have a walking foot for straight-line quilting and a darning foot for free-motion quilting. Some machines have a built-in walking foot while other machines have a separate attachment. Follow the manufacturer's recommendations for your particular sewing machine or equipment, and practice until you're comfortable with the techniques.

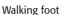

Walking foot Darning foot

Binding

Before binding your quilt, trim the excess batting and backing even with the quilt top and square up the corners and sides so that they are as straight and even as possible. Remove all excess threads. If you have not quilted up to the outer edges of the quilt, you may wish to baste closely along the edges of your quilt to prevent the edges from slipping while you're adding the binding.

To determine the length of binding you will need, measure all four sides of your quilt and add 18". Cut the binding strips 2" wide for a ¼"-wide finished binding.

1. Stitch the ends of the strips together on the diagonal to create one long binding strip the length you will need. Trim the excess fabric

and press the seams open to eliminate bulk. Trim the ends of the binding at a 45° angle.

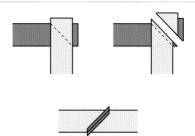

2. Fold the strip in half lengthwise, wrong sides together, and press.

3. Starting in the center on one side of the quilt, place the binding on top of the quilt top, with raw edges together. Start stitching several inches from the end of the binding. Sew through all layers and use a ¼" seam allowance.

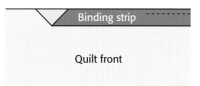

4. Stop ¼" from the corner. Cut the threads and remove the quilt from the machine. Fold the binding strip up, creating a 45° angle. Holding the 45° fold in place, bring the binding down so that all raw edges meet. Start sewing from the edge of the quilt, through all layers.

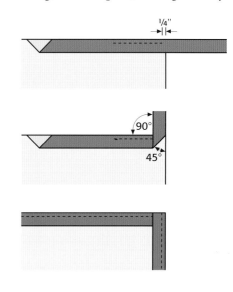

5. Continue around the quilt in the same manner. Stop sewing several inches from where you started and backstitch. Cut the threads and remove the quilt from the machine. Lap the starting end of the binding over the loose end. Mark a diagonal line even with the edge of the starting binding. Cut the binding end at a 45° angle, ½" longer than your mark.

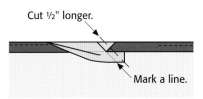

Cut ½" longer.

Mark a line.

6. Sew the two ends together, right sides together. Press the seam open to eliminate bulk. Refold the binding in half and press. Finish sewing the binding in place.

7. Turn the binding over the edge and hand stitch using a blind stitch. Make sure to cover the machine stitching. Miter each corner by folding down one side first and then the other.

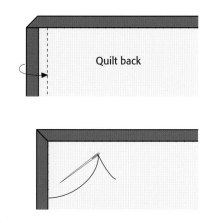

Quilt back

Labeling Your Quilt

Years from now, future generations will admire your work and want to know more about you. Be sure to label your quilt and provide as many details as possible. Include the name of the quilt; your name; your hometown, state, and/or country; and the date. You may wish to include other information, such as the recipient of the quilt, if it is a gift, and any other interesting background information. A plain fabric, such as muslin, is a good choice for your label. Be sure to use waterproof fabric markers to create your label. Sew the label to the back of the quilt as you would an appliqué piece.

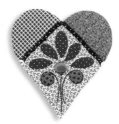

About the Author

Cynthia Tomaszewski plans to live to be at least 100 years old and loves to say "yes" to as many new adventures and experiences as possible. She says, "Life is for living! You should never have any regrets or have to say 'I wish I had . . .'" Her passions are quilting, appliqué quilts in particular, and travel, especially among exotic cultures. She believes it's the simple things in life that bring us the most pleasure. Cynthia loves reading, listening to New Age music, baking, bookstores, long walks, sunshine, beaches, wine, candlelight, "doing lunch," epic movies, flowers, antiques, writing letters, textiles, and a good cappuccino. She admits she's an incurable romantic, and although she works out at the gym regularly, she'd rather be shopping!

Cynthia operates her quilt design company, Simple Pleasures, from offices in Michigan and Abu Dhabi, United Arab Emirates, where she currently resides with her husband, Mike. She is the author of *Garden Party: Appliqué Quilts That Bloom*, also published by Martingale & Company.